CARING FOR CYNTHIA

A Caregiver's Journey Through Breast Cancer

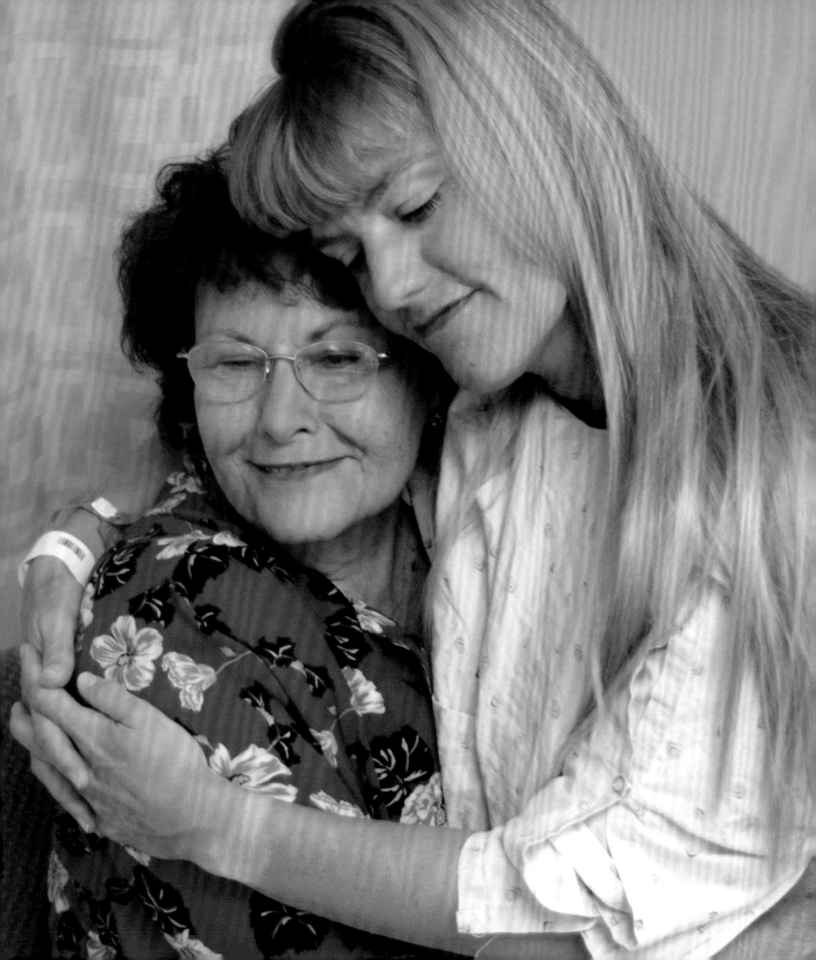

CARING FOR CYNTHIA

A Caregiver's Journey Through Breast Cancer

Photography by Amy Blackburn, RN, BSN, MA

Library of Congress Cataloging-in-Publication Data is available.

ISBN-10: 0-9769127-6-7
ISBN-13: 978-0-9769127-6-7

Manufactured in China by Global PSD
Developed and produced by Gary Chassman

VERVE

E D I T I O N S

www.verveeditions.com

Designed by Jennifer Barnicle
Edited by Lisa Dale Norton
Editing and proofreading by Elizabeth S. Shanley

10 9 8 7 6 5 4 3 2 1

Published by Verve Editions in association with Channel Trade Books
an imprint of Channel Photographics
PO Box 150338, San Rafael, California 94915
www.channelphotographics.com

Channel Photographics is a division of Goff Publishing Group

Distributed by SCB Distributors
15608 South New Century Dive
Gardena, California 90248
P: 310-532-9400

ISBN: 978-0-9773399-1-4

amyblackburn
PHOTOGRAPHY

Tucson, Arizona
Please visit www.caringforcynthia.com

To purchase copies of *Caring for Cynthia* as premiums or for corporate use, please email amy@caringforcynthia.com

For Mom and Dad

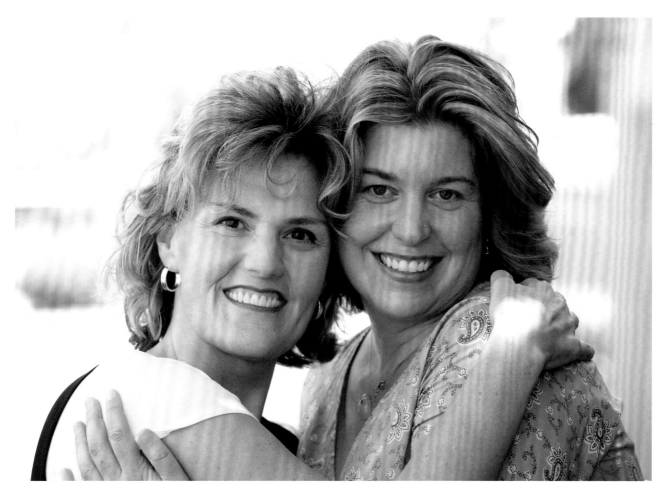

Cynthia and Amy

I'm delighted to be a part of something so beautiful and important. *Caring for Cynthia* is illuminating and encouraging for patients and caregivers alike. This is a book I will share with each and every coworker, friend, and patient whose life is touched by breast cancer.
—Cynthia

ACKNOWLEDGMENTS

This book is for those who provide care and support for others.

In the time that *Caring for Cynthia* was conceived and designed there were people in my circle of friends who were diagnosed with cancer or who succumbed to cancer.

Caring for Cynthia acknowledges those who established community for Joyce Duster, Sandra Kahn, Marilyn D. Adams, Diane Wakefield, Clem Nordsiek, Barbara Greene, Armando Romero, and Jacques in their journeys with cancer. It is heartening to know that their lives were illuminated by the unyielding support of loved ones.

This project would not have been possible without the gracious generosity of close friends and business partners who supported the project in a variety of ways:

Mom, Dad and Georgie Blackburn, Tom and Janice Blackburn, Cynthia Ogden, Milton and Karolyn Ogden, Stephanie and Rebecca Smith, Haroon Haque, Soheila Nouri, Ahyan Zia, Ruthann Valentine, Sam Abell, Leah Bendavid-Val, Mim Adkins, participants of the March 2006 Santa Fe Photography Workshop, Melissa Anderson, Debbie Shiring, Jill Malobicky, Deborah Knox, Ernie Nedder, Barbara Nichols, Sandra Morse, Anne Harman, Gail Roberts, Lori Ryder, Soozie Hazan, Meg Duarte, Janet Rae, Loti Gest, Devi Clinton, Bruce Bixler, Rex Rutkowski, Kathy Harenski, Robert Neidow, Mary Lou Rehak, Barb Bauer, Jill Brestensky, the participants of the October 2006 Self Expression Leadership Program, Aaron Reyes, Jeff Edson, Beth Ziegler, David Stefanovich, Mary Virginia Swanson, Tom Kiefer, Jennifer Barnicle, Gary Chassman, Darla Edmonds, Seamus Ford, Wei Yan, Dee Mazza, Martha Vazquez, Dr. Eric Whitacre, Anita Kellman, Dr. Michael Boxer, Vivian Athey, Lonnie Nenadovich, Kate Nighswander, Tony Tovar, Carolann Mashouf, Judy Bolander and Jacques, R. Thomas and Paulette Berner, Lisa Dale Norton, Judy Miller, Eliza Shanley, Chris Mooney and Balfour Walker/Chris Mooney Photography Studio.

During my years of work as a nurse, I have many times witnessed patients' strength and will to survive, the kind of will that defies all odds.

As an emergency room nurse, I care for people I don't know, positioned on stretchers and wheeled through automatic opening doors by paramedics. I share events occurring in patients' lives that change those lives forever, and even end some lives.

Perhaps I have a built-in defense mechanism that allows me to work in an environment where one day a man who feels as if he's swallowed a fishbone discovers he has throat cancer, or a stopped heart is revived and the patient is transferred to the intensive care unit. Whatever has given me the stamina to care for others, in my caring, I never grasped how fragile life really is. It wasn't until Cynthia, my best friend and internal medicine physician, was diagnosed with breast cancer that I became acutely aware of how short life is, how fragile.

I never understood how life for my patients and their families changed after a diagnosis. As a nurse, I offer support, answer questions, make phone calls, or hand out Kleenex once a physician has relayed ominous information from a chest x-ray or a CAT scan report. Then I walk out of the patient's room to care for a patient across the hall. Once Cynthia was diagnosed with breast cancer, I experienced the fear, pain, uncertainty, hope, frustration, elation, and helplessness that other patients and their families experience. As I accompanied Cynthia in her journey with cancer, I saw how life changes after a diagnosis, and I witnessed the support required to balance our existence.

Shortly after Cynthia's diagnosis, it became evident to me that she and I had embarked on parallel journeys. My journey explored a commitment to caring and to the impact giving had on others. Her journey was an exploration of inner strength and a commitment to survival. On my journey, I got into the trenches and experienced, on a level I could never have imagined, the impact of one's actions on another human being. While Cynthia's story is the key focus of this book another—unexpected—narrative developed during Cynthia's journey, a narrative pertinent to a caregiver: I, the caregiver, changed through my caring for Cynthia.

Breast cancer affected me. It scared me. I developed sympathetic symptoms in response to what Cynthia was physically experiencing: I felt a heavy ache in my chest after the mastectomy and an intermittent low level of nausea in the months that I cared for her. At times I wanted Cynthia's physician to ask how I was feeling or how I was doing. Thankfully the fear and the uncertainty of the diagnosis were softened by an outpouring of love and support from which Cynthia and I both benefited.

A "community of caring" formed from professionals, family, friends, and colleagues who stepped forward to support Cynthia's journey. They wove grace and unselfishness into their unending support, and, in doing so, illuminated a common thread: we are one through community, and each of us plays a pivotal role within that community.

I experienced the profound positive impact people have even when they don't realize they are making a difference. I witnessed how just being present can

comfort, even if no words are spoken. I saw how the simple act of lifting a garage door could keep a life on kilter. I watched as people who didn't even know Cynthia gave 110 percent of their energy and effort providing professional services in the weeks and months after her surgery. I learned how a simple run to the grocery store could make all the difference in the day of a breast cancer patient. Providing a ride to and from the cancer clinic, picking up the mail, and just talking about anything at any time during the day positively affected Cynthia.

The community that surrounded Cynthia enhanced her well-being and strengthened her will to survive breast cancer. This book illustrates those experiences. It charts the journey both Cynthia and I went on and creates a platform for healing by acknowledging that breast cancer affects even those not diagnosed.

Cynthia's network of supporters provided not only periods of respite for me, it also provided multifaceted levels of care that I couldn't offer her. When Cynthia's mom stayed with her after surgery; when Haroon, a colleague, studied with her in the evening; when her friend Lisa invited Cynthia to stay for the weekend after a chemo treatment—and all the other times people willingly boarded the ever-changing course of our journey—I was affected. I was invigorated and bolstered by the community's giving spirit. Each one of those friends—all of us working together without a script or a roadmap—taught me something.

There is not much beauty in the emotional challenges and hardships faced on a journey with cancer. There is, however, beauty in emotional vulnerability and the overall presence of the passion to give and to receive that rises during a journey with cancer.

This book is about breast cancer, but, more importantly, it is about the beauty of simply sharing ourselves.

At one point in my friendship with Cynthia, our favorite pastime was taking long walks. Sometimes we would walk farther than we'd planned, kicking along, letting the words tumble, just because we were all knotted up in some serious discussion about our careers, men, relationships, or love.

One evening we paused at the end of a walk along the Rillito Wash in Tucson, marveling at the yellows, blues, reds, and oranges of the sky as the sun set gracefully before us. Once we arrived at the parking lot, we noticed people talking quietly, looking east. As we turned, we saw it: a great harvest moon cresting the Catalina Mountains. Like the others that evening, we settled on top of the car and watched as the moon continued its ascent well above the mountains. For a short time, there were no words. Now and again it is this way when silence feels as precious as a long, heartfelt conversation.

Sitting in silence, present to one another and present to the moment, is one of the sweetest ways we share ourselves. I found this to be especially true during the months of caring for Cynthia.

I was at home when the call came. All I could hear was wind and the sound of someone walking. I knew it was Cynthia, my best friend.

Months before, Cynthia, who was forty-one at the time, had felt a lump in her breast while doing a self-exam. She told her doctor about it and a mammogram and biopsy were scheduled. The mammogram came back negative, and the biopsy identified the lump as benign.

Then Cynthia's gynecologist sent her on for a second opinion from a surgeon. It was my number she dialed when she left the appointment. I waited for the noise to subside. Then came Cynthia's voice:

"Amy, I've just left the surgeon's office. He used the words 'highly suspicious' to describe the irregularity. I had another biopsy, and my breast's a little sore."

"Are you all right?"

She said she was.

Five days later, Cynthia learned the results of the biopsy report. I wasn't with her when she got the phone call, yet Cynthia has spoken of that call so often I know the events by heart:

Our mutual friend Haroon was scheduled to pick up Cynthia after work to go for a spin in his new convertible and a walk in the park. As she waited for Haroon, Cynthia's phone rang. It was the surgeon. "Cynthia," he said, "the biopsy is positive. You have breast cancer." As she hung up and began to cry, Haroon arrived in his new Mustang. Later she said she noticed Haroon's new car but simply could not talk about it. Instead she insisted they drive to the park and maintain their evening routine. As Haroon

and Cynthia walked, instead of weather, politics, or hospital talk, the two discussed suffering, faith, and inner strength. Cynthia recalls that initial conversation as a great source of comfort in those first few moments after her diagnosis.

From the park, Haroon drove Cynthia to my house. As I heard the car pull in, I stepped outside to greet them. Rising moonlight illuminated the activity in my driveway, and as I watched Cynthia get out of the car, I could see tears on her face.

"I have breast cancer," she blurted. Her hand reached to her tearful eyes. In that pause at the end of the sentence, I was speechless and numb.

"Can you take a picture of me tonight—just the way I am right now?" The three of us hurried into my home to record the raw emotion of that night.

By and large, Cynthia's presence encourages laughter and vibrant conversation wherever she goes. On that night, however, the three of us were silent. Under the studio lights, I saw a stoic woman in a black sports bra and polyester running pants, void of expression. Cynthia cried, then regained her composure. In the seven exposures I created that evening, there was already evidence of Cynthia's courage surfacing.

Much later I came to realize that Haroon and I were seeds planted to become the first growth of a community of professionals, family, friends, and colleagues that would sprout into a garden that enveloped Cynthia and provided support and care during her illness with breast cancer.

In the dark of that night in my home, though, I had no idea how much my life would change in one year.

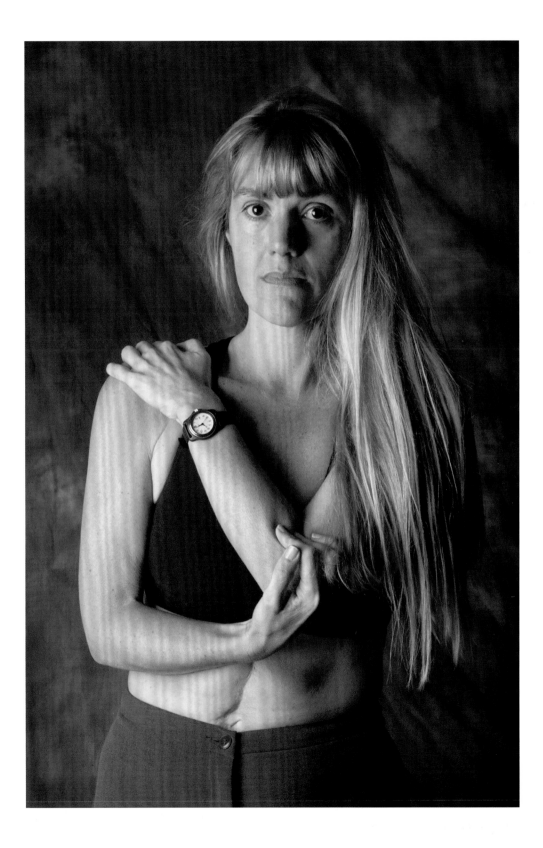

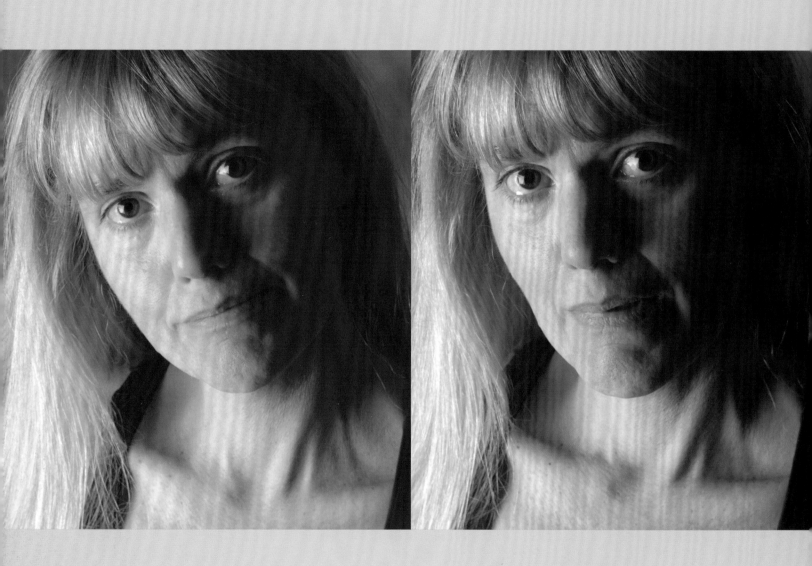

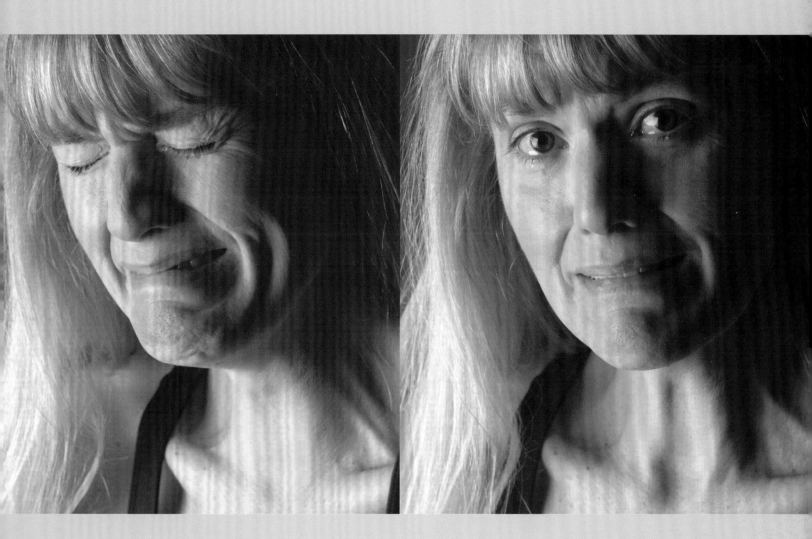

Can you take a picture of me tonight—just
the way I am right now?

CYNTHIA

SPIRITUAL SUPPORT

Cynthia and I met while working as medical staff on the San Carlos Apache Indian Reservation in San Carlos, Arizona. I worked as a registered nurse on the reservation for three years, while Cynthia dedicated seven years of her internal medicine career to the San Carlos Apache tribe. During her time on the reservation she obtained a commercial driver's license (CDL). While walking for exercise one evening, I had to ask her why. What motivates one to obtain a CDL outside of wanting to be a truck driver? "I drive the children to church on Sundays," she said.

Her commitment to the children's spiritual learning was part of a relationship she had established with a church in Globe, Arizona. Globe is a copper-mining town west of the Indian reservation and a twenty-five-minute drive from the San Carlos Hospital. It's a small, bustling place where people traveling to the north country of Arizona stop for food and fuel.

Back in the days when Cynthia and I lived on the reservation, Cynthia had developed a close spiritual connection with the youth pastor at the Globe church, Pastor Ralph. That connection continued even after Cynthia left the reservation, so when Cynthia called to tell me that Pastor Ralph and others from the Globe and the San Carlos communities planned to drive to Tucson to pray at Cynthia's home that evening, I was not surprised. I was shopping at the time but immediately finished my errands and drove directly to her home, intrigued to see what was being planned.

That evening I watched Pastor Ralph anoint Cynthia's head with oil and the entourage bless her, the kitchen, the bedroom, and the home before making a circle around Cynthia to bless her more. Afterwards the prayer circle sat down, and I heard Cynthia talk about her emotions for the first time since the diagnosis. She said she felt more scared than she thought she'd feel and went on to say that she wanted to live "another forty years whole-heartedly." She spoke of unfinished business regarding places she wanted to travel, participation in education related to tropical medicine, and volunteerism in mission or relief work.

As the evening closed and we gathered at the front door, Cynthia said, "Pray for a miracle." She requested a specific prayer: "Pray for my lymph nodes," she said. "Pray that they are clean." And as she opened the door to say good-bye, she calmly and matter-of-factly announced that her mastectomy was scheduled for April.

As I walked to my car, I realized I had less than a month to prepare for the event that would change my best friend's life. I was blind to the fact that cancer would change my life too.

As I walked to my car, I realized I had less than a month to prepare for the event that would change my best friend's life. I was blind to the fact that cancer would change my life too.

Shortly after Cynthia's diagnosis and surgery, a bilateral mastectomy, were confirmed, her brother's and sister's families arrived for a previously planned family vacation.

The timing was perfect since surgery was about three weeks away—plenty of time to live it up, so to speak, before the surgery. Cynthia invited me to join her family in the activities, and it was wonderful to be a part of the strength in family togetherness through the presence of her young nieces and nephews, and brother- and sister-in-law. Together we went out for meals, read, watched videos, swam, and laughed over jokes, all good medicine for Cynthia (and me).

While the rest of the family went sightseeing in Tombstone, Arizona, Karolyn, Cynthia's mother; her sister, Stephanie; and I accompanied Cynthia to the plastic surgery consultation. Here Cynthia explored the possibility of breast reconstruction.

In the exam room, she and the physician had a matter-of-fact discussion about her breasts, her level of physical activity, and the musculature of her chest and back. The physician also provided a broad overview of reconstructive surgery.

The four of us hovered around the physician's desk as we felt the texture and weight of various implant samples and commented on photographs we saw in a book of before-and-after photographs of reconstructive surgeries.

The consultation took place in a small, narrow room. Cynthia stood with her arms lifted. The physician stood in front of her, obscuring my view of Cynthia's exposed breasts as he purposefully felt her neck, sternum, and chest.

The room was quiet as we watched his manual assessment of her body. While I've watched many physicians assess patients, I had never seen a loved one or a family member's body felt for such an exclusive reason as breast reconstructive surgery. There was a moment when the consultation felt like a tunnel into a dream: I'm a nurse in a plastic surgery office, there's a patient before me, the patient has long blonde hair similar to my friend Cynthia's hair

Cynthia broke the silence with several questions: How long does the implant procedure last? What are the differences between silicone and saline implants? How is the nipple created and how many surgeries are required before the implants are complete?

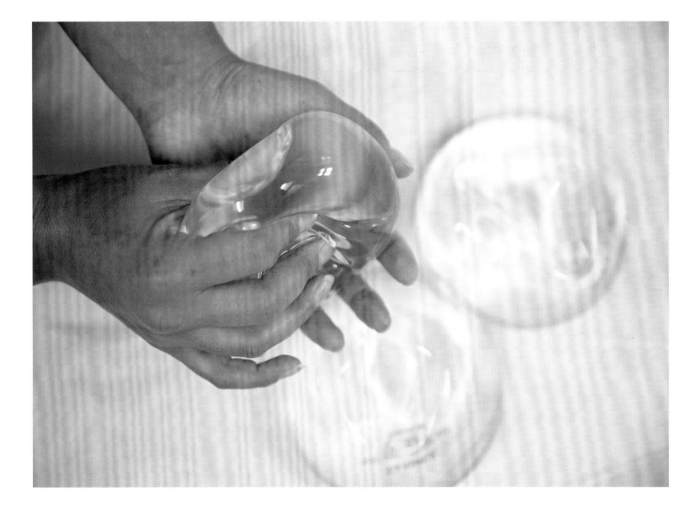

I accompanied Cynthia and her mother to an appointment at the Arizona Cancer Clinic to meet the oncologist. It was my first visit to a cancer center. The three of us appeared calm on the outside; yet I felt extremely "somehow." Somehow was a word to describe feeling not quite right that Cynthia and I had learned while working on the reservation.

As we approached the electric sliding doors of the cancer center, the denial of cancer completely faded for me. When I walked through the cancer center entrance, the acceptance phase of cancer began. Physically being at the cancer center meant that cancer was really happening.

Cynthia stepped up to register while her mother and I took a seat in the waiting room. Cynthia was given a beeper to hold, similar to the beepers that vibrate once a hostess is ready to seat a party at a restaurant. We made a funny comment or two about the fact that we certainly weren't at the Olive Garden. Then we sat back and settled in to wait.

Nervousness and not knowing what to expect left me feeling slightly nauseous as we sat in the waiting area. I read through magazines, looked at wig brochures and various advertisements for local businesses selling products for cancer patients. We chatted among ourselves, and soon the magazines didn't offer much distraction. I started to think of things to do that I could have brought with me. More time passed and my mind wandered outside our three-chair area.

I began to watch the people sitting around me as well as the others entering the center and making their reservations with the "hostess." As time continued to pass, even an interest in watching people dissipated, and I couldn't keep from noticing the time.

I revisited the same magazines and, again, looked at the people around me and finally became fidgety, almost desperate for something to hold my attention. I looked above me and noted the architecture.

The waiting room was a tall box illuminated by natural light from windows that lined a ledge of balconies. I squinted my eyes and followed the thick white lines of the painted balconies that distinguished each floor of the building. The architecture was nothing but white lines and a white ceiling until my eyes came to a green plant overgrowing one of the balconies. It interrupted the continuum of the white box. The green leaves of the plant seemed to be floating against a background of white space. I must have lost myself in the white lines. I don't know how long my neck was stretched to look upwards. Taking a break from my daydream I noticed others around me looking up. Then Cynthia looked up. "Before I knew you," she said, "I would have never noticed that sort of beauty."

We waited three hours to meet the oncologist that day.

FIRST VISIT WITH ONCOLOGIST

Cynthia had researched breast cancer since her diagnosis and was fully prepared for her first oncology visit. She brought a list of questions. I, on the other hand, had done no research and had no questions formulated for the oncologist.

Karolyn and I were in the exam room when the oncologist stepped in. After brief introductions, Cynthia and the oncologist began to speak medical lingo to each other. In fact they spoke like colleagues discussing a patient's case. Eerily, the patient case being discussed was Cynthia's.

In contrast to Cynthia's preparedness, I hadn't read any information about treatments, procedures, the role of the hormone estrogen, or probable mortality rates based on various treatments, so when the oncologist and Cynthia spoke, I did not understand their conversation.

My body felt heavy in the chair and suddenly it seemed like I was listening to Charlie Brown's schoolteacher from a distance. The conversation became muddled, and I turned inward, perhaps in a purposeful attempt to not hear what was being said. When it ended, I didn't know what had just been discussed.

Leaving the exam room, I was detached. I felt as if I had offered no support during the visit. I had no feedback, no opinions, and had said very few words. Rarely do I sit so quietly with nothing to say in Cynthia's presence.

Weighing the options for breast cancer treatments is not easy. Cynthia took time to get a second opinion from another oncologist.

She exhausted the Internet, looking for resources related to breast cancer and statistics of various treatments for breast cancer. Then she took her own knowledge of breast cancer, the information gained from the first oncology visit, and her colleagues' support, to another oncologist for a second opinion. Two physician colleagues, Haroon and Soheila, accompanied her to this appointment. The four of them had an open discussion of treatments and statistical predictions of survival related to the treatment she'd choose.

As Cynthia took days to consider her treatment options, her mother said to her, "This cancer is your cancer." Only Cynthia could choose the treatment she felt would best suit her. Cynthia recalled a conversation with a close friend who suggested she try everything in her journey to survive cancer. Those conversations powerfully assisted her in defining the treatment course for her cancer.

Looking back, Cynthia says she wanted those around her to accept her decisions about the treatments she'd chosen. Having that acceptance and support, she said, was a profound source of strength.

After her diagnosis, I accompanied Cynthia to a second oncology visit. In the exam room, I listened as she and the oncologist discussed her case.

Cynthia asked about the possibility of NOT losing her hair. Almost immediately, not only was hair loss confirmed, but the oncologist estimated the date by which she would lose her hair. I heard, "You will lose your hair approximately seventeen days after the first dose of chemo." Cynthia and I glanced at each other and nodded our heads.

As we walked out of the exam room, I was overcome with unimaginable helplessness. As if the diagnosis of cancer wasn't enough, each day, each week, brings more that is unsettling. The emotional devastation of the diagnosis is quickly overshadowed by other emotional traumas that occur throughout the course of treatment: diagnosis leads to radical invasion of the body, which leads to hair loss and other side effects associated with chemotherapy, and on and on.

Small triumphs in the day become milestones; simple pleasures reside close to the heart.

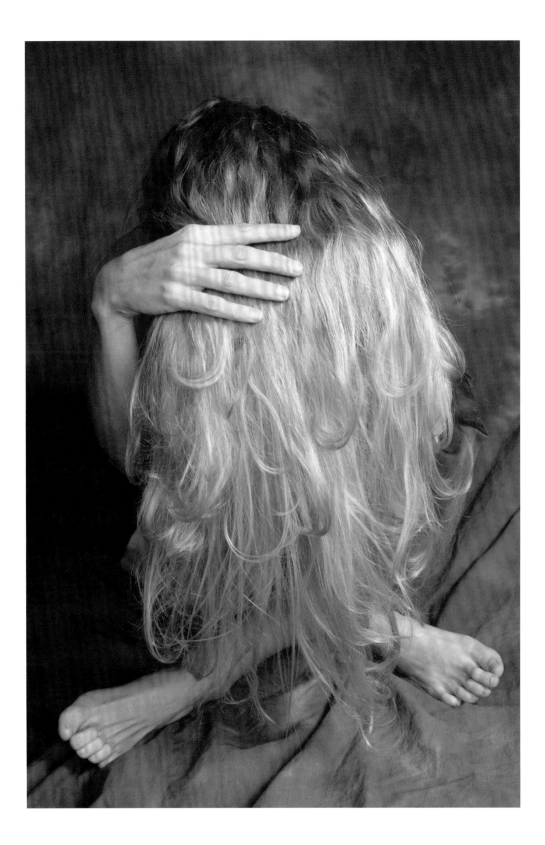

While walking one evening, Cynthia shared a story about an experience she had during a massage. She told me she wept through most of the massage until her therapist asked if he should stop. She insisted he continue and, while massaging her feet, he quoted the Gospel according to John and said, "I'll be with you always." After she heard her therapist speak Christ's words aloud, she described feeling great peace.

My interpretation of her experience is that a powerful presence in her life was reaffirmed as she lay on the massage table. I believe the fear of the upcoming months was replaced with a certainty that she would be accompanied on her journey. This certainty brought peace as she stopped crying.

Cynthia called what she experienced that day "the peace that passes all understanding."

At the time, I did not realize a key element to progressing more deeply into the journey with cancer requires a shift where the patient can access an inner strength and develop a new, powerful position from which to face challenges. For Cynthia, I believe this massage practitioner created an opening through which Cynthia shifted her stance as she faced breast cancer. His healing touch single-handedly transformed Cynthia's reactions to great challenges that we knew lay ahead in her journey with cancer.

In the remaining weeks before surgery, Cynthia was noticeably different. She was peaceful, and there was courage and intention when she spoke from that point on.

Inside this transformation, I understood that anyone who did anything to support Cynthia contributed to her well-being and, perhaps, her survival.

Inside this transformation, I understood that anyone who did anything to support Cynthia contributed to her well-being and, perhaps, her survival.

On the day of Cynthia's surgery, I awoke without an alarm. Despite feeling rested, I stayed in bed. Amid my pillows, I tossed and turned as I consciously considered the day's sequence of events. My head felt as if it weighed one thousand pounds. I could not lift it from the pillow.

If I did prepare for the day, it meant going to the hospital. And if I did go to the hospital, it meant Cynthia would have surgery. In a way, I was a part of making her mastectomy possible, and I didn't want her to have a mastectomy or to have breast cancer. Escorting Cynthia to the hospital felt like a heavy burden; it was this burden that made my body feel too heavy to move.

I kept wondering: why had Cynthia selected me to drive her to the hospital? And then something happened. I realized I was the chosen one out of all the people available to drive her. She chose me.

Quickly and attentively, I rose from my bed and gathered my camera gear. Minutes raced by on my bedside alarm clock. I realized I couldn't shower, eat breakfast, and prepare my bags and camera gear before 7 a.m. My heart beat rapidly as I showered. I threw towels, left kitchen cabinets open, and tossed clothes as I rushed not to be late to Cynthia's house.

Once there, I transitioned from chaos and disorder to an even-keeled, emotionally stable, on-time person. As I walked through the door, I heard: "Amy Sue . . ." and then, "do you think I'll need this? Do you think I should take this with me?" When Cynthia asked questions, I thought: I've never done this before. How can I know what she'll need at the hospital?

I answered her questions the best I could with "I don't know's" and "yeses." Since hospital environments are generally cold, it was yes to bringing long-sleeved shirts and "Let's bring them anyway," to the question of socks.

We loaded the car with snacks, beverages, extra clothing, Cynthia's Bible, and her favorite pillow. Cynthia's family took one car, and I drove Cynthia in my car with her niece Rebecca. During our drive, we listened to the radio and heard Jack Johnson sing lyrics that echoed all the way from the driveway to the hospital: "I tell you one thing, it's always better when we're together. Hmmm. It's always better when we're together. Yeah, it's always better when we're together."

We packed the car similarly to having packed for a weekend road trip, and, with the background music, it seemed as if we should be driving north to access the interstate that would take us to northern Arizona to go hiking in Flagstaff. Instead I made a right-hand turn out of the driveway and we drove in an unfamiliar direction.

While neither of us knew what lay ahead, the ride to the hospital was full of companionship and it felt like everything could be better, according to Jack Johnson, if we were together. The windows were partially down, and the morning air blew through our hair. I looked at the rearview mirror and saw eight-year-old Rebecca in the back seat, her young presence a symbol of innocence and vitality.

While we drove, I thought: Did I answer her questions correctly? Do we have everything we will need at the hospital? Am I doing everything right? Is there something I should say?

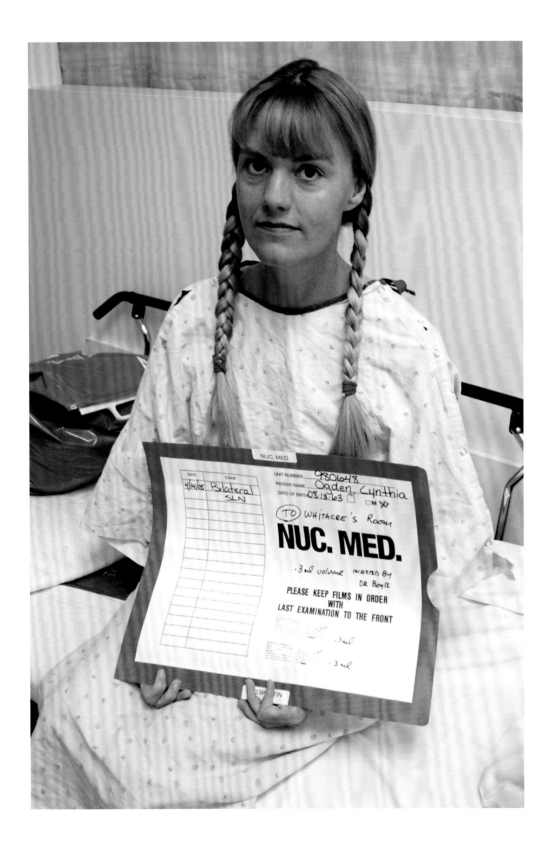

Before surgery Cynthia underwent an intravenous injection of radioactive dye to determine if the cancer had spread, via the lymph nodes, to other portions of her body. Performed in the radiology department, the injection of radioactive dye assists the surgeon in determining what tissue to remove.

From the preoperative holding area, Cynthia was escorted by wheelchair to the radiology department. Karolyn and I walked beside her and, once in radiology, the three of us waited for Cynthia's name to be called.

As we waited, Cynthia and her mother held hands, and I buried my head in a magazine in an effort to hide the tears I was holding back. Watching them hold hands reminded me of the comfort I'd find in holding my mother's hand during a time so critical as this.

I could have held Cynthia's hand, yet I knew that there was no substitute for a mother's hand.

Once finished with the procedure, we were escorted down a long, sunlit hallway back to the pre-op holding area.

I watched as Cynthia, Karolyn, and the escort staff walked through pockets of bright sunlight from windows that offered a temporary escape from the reality of being prepared for surgery. Wasn't it just yesterday that Cynthia and I walked twelve miles along the Rillito Wash? Seeing her wheeled through a hospital felt unreal.

Outwardly she appears as she always has: athletic and muscle-toned. The truth is, the mystery of the cancer growing inside her keeps us both from understanding how sick she may be. As a physician, Cynthia has always been the one to provide care to others. Today, though, the roles are reversed.

I have never seen her look so fragile.

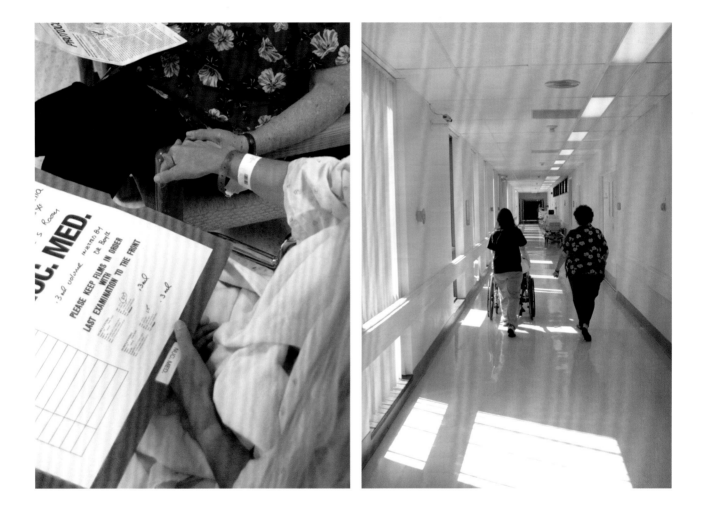

In the preoperative holding area, Cynthia was allowed visitors. One by one, family and professional colleagues dropped in to deliver hugs and words of encouragement.

Some friends brought oil to anoint Cynthia's head. Then hands were laid on her during a prayer. Her surgery was only minutes away.

When the prayer ended, her friends stepped away from the prayer circle; the nurse checked the cardiac monitor and recorded the vital signs. The blood-pressure cuff was disconnected with the harsh ripping sound that is the trademark of Velcro. I watched Cynthia board the stretcher and the nurse cover her with blankets.

I said good-bye as the nurse released the brakes of the stretcher and raised the side rails. The metal click that accompanied that gesture was very familiar, typically mundane to me in my vocation as a nurse, but this day the sound was significant.

As I walked out of the preoperative holding area, I heard a nurse say, "The OR called. They're ready." The sound of the stretcher wheeling down the hallway faded as I left the holding area. I didn't stop to look back. Instead I walked with Cynthia's family toward the door to the surgical waiting area. In the waiting area, we regrouped and, since it was close to noon, left the hospital grounds and went to a local restaurant.

This particular dining experience was different from earlier meals with Cynthia's family. Things weren't the same without Cynthia. I sensed a collective understanding that as Cynthia's life was changing within the confines of a hospital operating room; our lives were changing, too.

As we perused our menus, I masked the emotions I felt from the morning at the hospital. I had no appetite.

As the waitress took our order, she talked about Tucson's unusually hot April weather, and, for a moment, we were distracted from the seriousness of the day. Then Stephanie started asking me questions about genetic counseling and, by the time the salads arrived, I was holding back tears.

All I wanted was the day to be over quickly. Instead time seemed to stand still on that hot April day.

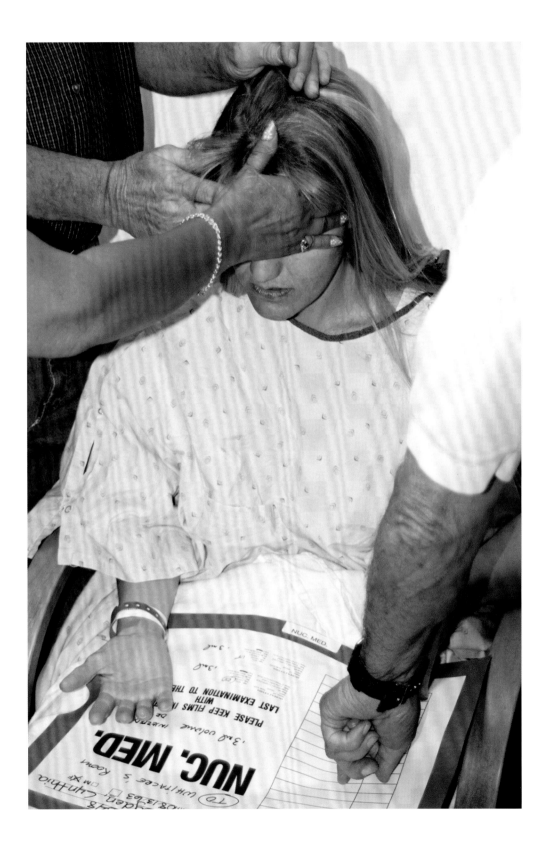

SURGERY

After lunch we returned to the surgical waiting area. It seemed the surgery was taking longer than I thought it would. I grew sensitive to everything that happened in the room. When a vase of flowers was delivered, I wondered if the flowers were for Cynthia. Each time the doors to the recovery room opened, I thought Cynthia's surgeon would step through to speak with us. When the phone rang, I thought it was someone who wanted to reach one of us. I perched on the edge of my seat waiting to talk with anyone who could tell us anything about Cynthia's surgery.

Perhaps I had a look of concern on my face. Soon Cynthia's mother began to pace the waiting area. She too peered into the recovery room each time the automatic doors opened. I had never waited for a loved one or a family member in surgery, and I just thought that feeling anxious and apprehensive was the only way to be. I may have learned this from watching television—I'm not sure.

One thing I am sure of today, however, is that for me, the time spent in the surgical waiting area was a lesson in patience and in letting go of expectations. The afternoon could have gone another way for me. I could have read a magazine, drank iced tea, and rested in preparation for the events to come, events that would require my attention and energy. Instead my energy was zapped away as I grew more and more nervous about expectations I had regarding the outcome of the surgery and the weeks that lay ahead.

The reality is that surgery will take as long as it will take. Many factors contribute to the length of a surgery. And as for waiting times in waiting areas, well, that day was just the beginning of experiencing the word "wait."

I had never waited for a loved one or a family member in surgery, and I just thought that feeling anxious and apprehensive was the only way to be.

After surgery, while Cynthia was waking from anesthesia in the recovery room, her sister and her niece Rebecca gathered close to the stretcher to greet her as she awoke. Her mother stayed near the side rails too and used ice chips to wet Cynthia's dry lips. While we were positioned around Cynthia, the surgeon emerged from behind us. We stepped away so he could see Cynthia. I asked him directly about lymph node involvement. "The lymphs were clean," he said.

I didn't believe Cynthia heard what he said and therefore repeated the good news. She used her hoarse voice to thank the surgeon and thank God. Cynthia's tears were noticeable as she gripped Stephanie's hand.

Breast removal, also called a mastectomy, can be an outpatient surgery. Cynthia's hospital check-in, preoperative procedures, surgery, and recovery added up to an eight-hour day.

After some time in the recovery room, the nurse began discharge instructions and outlined the care of the drainage tubes. As a nurse, I've been providing discharge instructions for years. That day I was on the other side and, instead of speaking, I was listening. I had to listen intently; the information gained was critical should Cynthia require medical assistance beyond what I could provide in the next twenty-four to forty-eight hours. And even though I was familiar with drainage tubes and postsurgical care, I felt my heartbeat pounding in my ears as I listened to the nurse.

Once the word "drain" was mentioned, Cynthia looked at her side. About six inches underneath her armpits were drains that looked like lightbulbs at the end of a flexible straw. They had been surgically placed under the skin to remove blood and protein-filled fluid. I heard the nurse say it was time to pull the car around.

As I approached the outpatient entrance, I spotted Cynthia surrounded by her family. They helped her into my car, and we pulled away from the curb. Cynthia settled into the front seat and rolled down the window to feel the air. As I drove, I felt numb, as if the anesthesia had been administered to both of us. Cynthia sat quietly, her eyes closed, opening them only briefly to talk, although few words were spoken.

That evening five of us gathered in Cynthia's living room. Several people curled on the shaggy rug below Cynthia on the couch. She was surrounded by flowers, gifts, and cards sent from as far away as the East Coast. The conversation was light, and there was even some laughter despite the long day.

It wasn't long before I suggested Cynthia sip some water and take a short walk around her condo complex. Two of us accompanied Cynthia for a fifteen-minute stroll.

Once back inside, I helped Cynthia with the pain pills, the bandages, and the drainage tubes. I milked the tubes, emptied the bulbs, and measured the red-tinged drainage that came from each side of Cynthia's chest.

Karolyn took over at that point, and I headed home despite the pull I felt to stay with Cynthia through the night. Thankfully, though, her mother would manage those hours and allow me to rest in preparation for the next day.

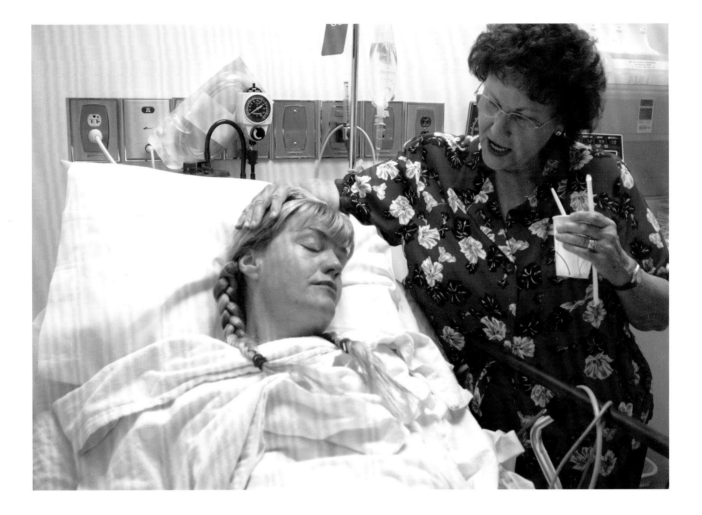

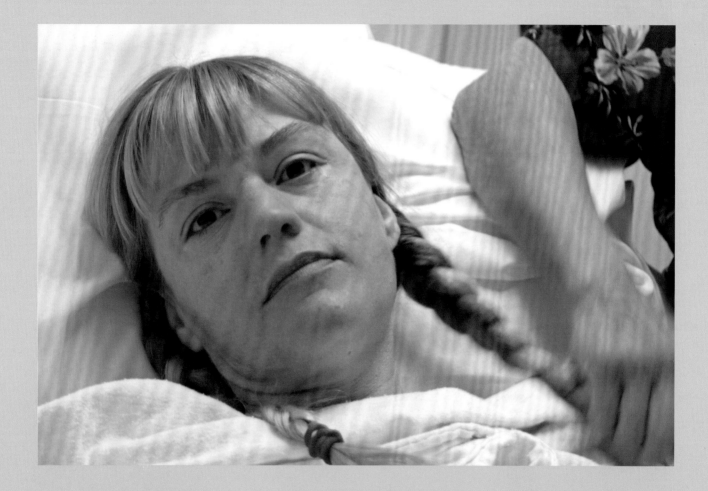

Breast removal, also called a mastectomy, can be an outpatient surgery. Cynthia's hospital check-in, preoperative procedures, surgery, and recovery added up to an eight-hour day.

The next day, Cynthia stood in front of her bathroom mirror with her upper torso wrapped in a six-inch Ace-wrap dressing. I watched with my camera. First, Cynthia took off the drainage bulbs that were safety pinned to the dressing. As the bulbs hung by her side, she took a large sip of water and set the glass down. Then she paused a moment, looked at me, looked at herself in the mirror, looked down at her chest, and began to slowly unwrap her bandage.

Each layer of wrapping had more dried blood the closer she got to the incision. Once the incision was exposed, she looked up to the mirror and then turned to me.

There was silence. There were no tears.

I assisted her into an expandable mesh dressing that fit her like a tube top to hold the new gauze placed on the incision, then watched as she buttoned her blouse. Right away we noticed how the extra material puckered where her breasts would have been.

Karolyn came into the bedroom holding costume coconut-and-seashell bras. Both Cynthia and her mother laughed. It was the perfect distraction to lighten the moment. Karolyn reached for Cynthia and kissed her. The two began to make plans to shop for a camisole with material "breasts" built into the fabric so her shirts would look more natural.

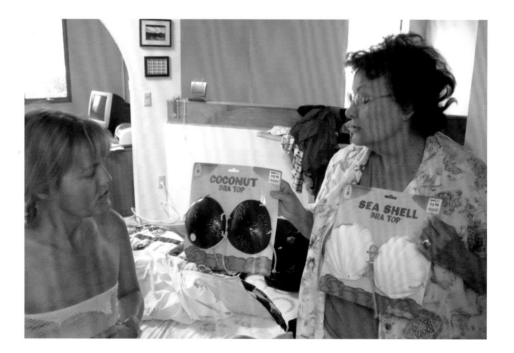

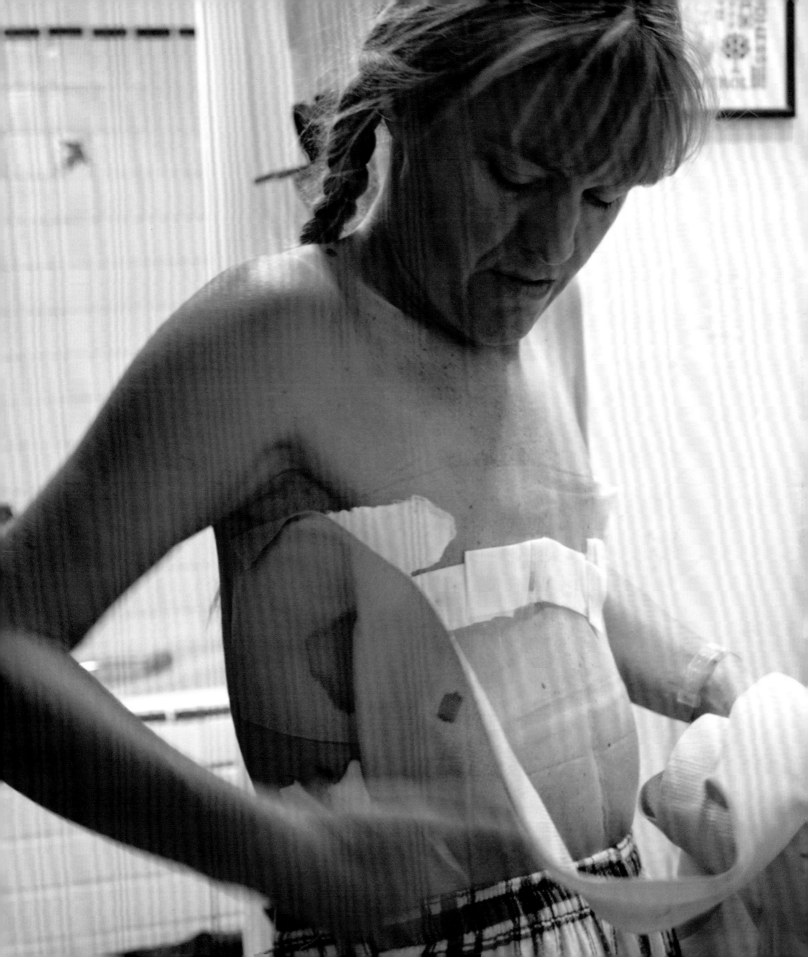

THE DRAINS

Every day the fluid in the bulbs on each side of Cynthia's chest had to be measured. One day the left side had 15 cc of fluid and the right side had 30 cc of fluid. The next day, the fluid levels changed. It went like this: one day she would have limited fluid in the bulbs, and we would think the drains would be removed, then, the next day, she would have more fluid in the bulbs, and we'd realize the drainage wasn't done.

These drains were one of the most intolerable aspects of breast cancer for Cynthia. Cynthia said the drains took on a lifelike feel when she moved, similar to "long worms." After days of psychological and physical discomfort from the drains, she insisted upon their removal.

Normally drainage tubes are removed once the fluid stops, or the fluid is at a level that can be reabsorbed by the body. In Cynthia's case, she requested premature removal of the drains. Once removed, Cynthia's chest hurt because the fluid accumulated underneath the skin. Since she had no drains, Cynthia had to go to the surgeon's office every few days to have the fluid removed with a needle. It was weeks before the drainage ceased, longer than either of us expected.

After a mastectomy, clear, odorless drainage is normal. There is no way to define the amount of drainage or the period of time the drainage will persist. The fact is that the amount of drainage changes each day, and the drains are discontinued when it's time.

Time, then, is a variable in the healing process. Each patient will experience this period uniquely.

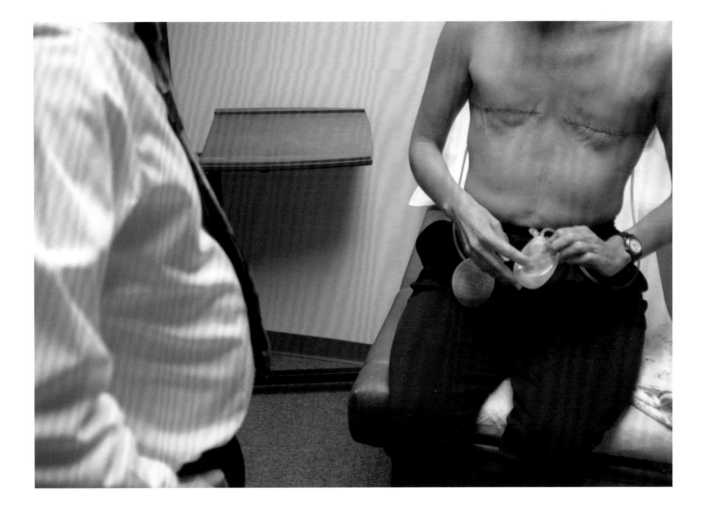

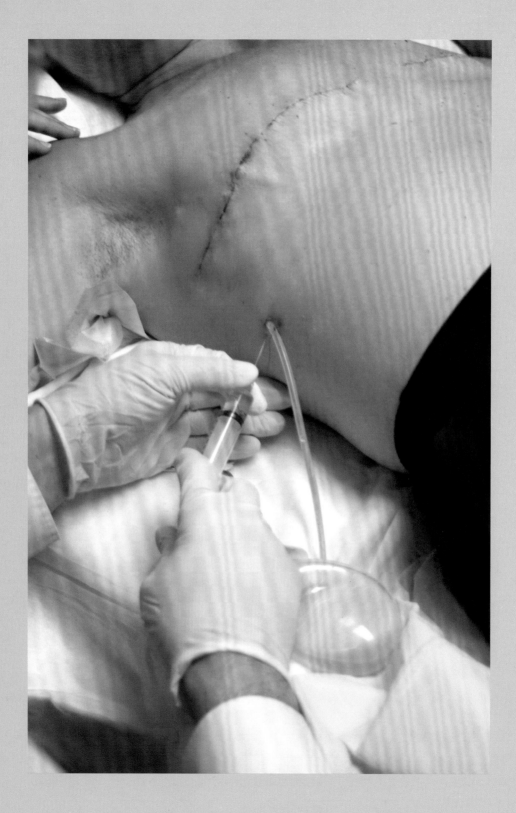

After a mastectomy, clear, odorless drainage is normal. There is no way to define the amount of drainage or the period of time the drainage will persist. The fact is that the amount of drainage changes each day, and the drains are discontinued when it's time.

As we waited, my mind was foggy. The waiting room was like a scene out of a movie, like it was not really happening. I wished it was a movie.

Three weeks after the drains were removed and Cynthia's body was well enough for chemotherapy, I went with her to her first treatment. We waited for her blood to be drawn. Then we waited for the results of the blood tests. As we waited, my mind was foggy. The waiting room was like a scene out of a movie, like it was not really happening. I wished it was a movie.

After getting the blood results, the pharmacy department was supposed to mix the chemo that Cynthia would receive. We thought we were waiting for that when one of the nurses approached and reported the lab work revealed Cynthia's white blood count was too low to receive the first dose of chemo. We looked at each other, and the only word that came out was, "Okay." Cynthia received an injection of a medication to boost white blood cell production, and then the nurse instructed Cynthia to return the next day for additional blood work to recheck the white blood cell count.

We put so much emotional energy into preparing for this day. Was I relieved that Cynthia didn't receive chemo? Had we experienced a setback in the course of treatment? My emotions were in a jumble. I felt discouraged and helpless as we walked out of the cancer clinic that day. I wanted to blame someone or something: the cancer center, the cancer itself, or even the white blood cells.

We returned home to a driveway full of friends. Cynthia went for a walk to shake off the day, and I returned to my home.

I found myself tidying and then finally cleaning my home. Here I had control. As I worked, I focused on faith and trust, and prepared myself for all that would occur beyond my control in the months ahead.

When Cynthia returned to the cancer clinic the next day, her white blood cells were at the level required before the chemo treatment. She received her first dose of chemo that day and thus began the four months of eight cycles of chemo treatments. Cynthia would receive chemo every two weeks depending on her white and red blood cells' ability to recover from the previous dose of chemo. She would receive medications to boost both red and white blood cell production.

Because the chemo compromised her body's ability to fight infections by decreasing the number of white blood cells available to attack germs that invade the body, Cynthia took measures to stay as healthy as possible. She would wear a mask, if necessary, in public to avoid exposure to germs.

We quickly learned that since fresh foods and flowers carry germs, Cynthia couldn't eat fresh vegetables, salads, or even be around freshly cut flowers. With this information, Cynthia and I were going to face a summer without salad, which had been one of our favorite shared meals.

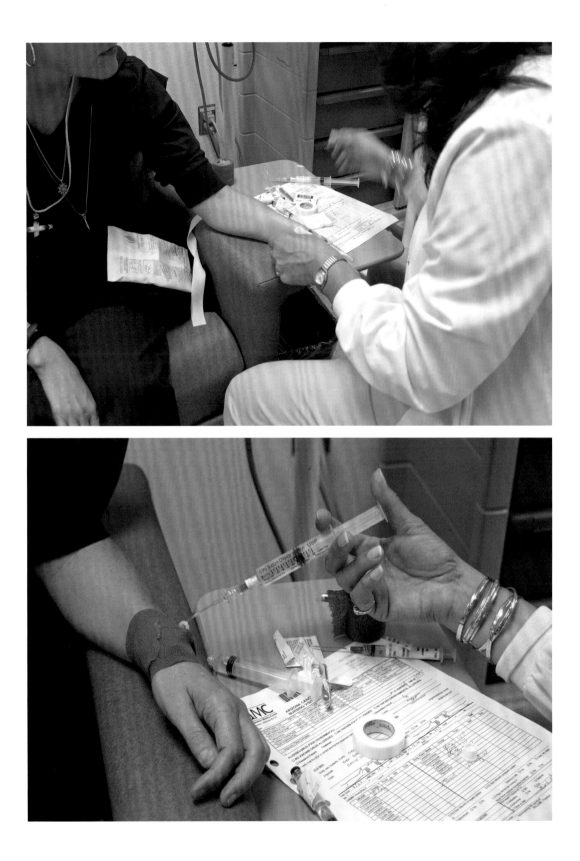

NEW IDENTITY

I knew Cynthia valued her hair more than her breasts. Her hair was naturally silky and blondish brown in color. Her hair was long, almost to her waist, and had been since childhood. Washing, conditioning, and combing her hair took hours, a fulfilling ritual that was a part of her existence. Her longtime coif was an obvious part of her identity.

Several days after the aggressive chemo regime began, we knew total hair loss was only weeks away. We spoke affectionately of her hair during this time and reacted to the anticipated loss by memorializing it. Perhaps the photo session was a necessary part of the grieving process on our journey with cancer. As we began this series of portraits, we knew Cynthia's hair would never look the same.

In typical fashion, Cynthia took steps to control what she could. She reacted to the anticipated hair loss by working closely with her longtime hairdresser, Tony, to create a new look with shoulder-length hair. She did this as she prepared for baldness in about two weeks.

While Cynthia consulted fashion magazines for short hair ideas, in the end she entrusted her new look to Tony's creativity and experience. She climbed onto the parlor chair. Tony tied the plastic hairdresser apron behind her neck and handed her a brush.

Without speaking, Cynthia began to brush her long hair, I believed, for the last time in her life. She brushed for several minutes, and then Tony stepped behind her and made a ponytail with her hair, using a black rubber band. With one snip of his scissors, her long hair was gone, placed in a plastic bag, and ultimately donated to Locks of Love, an organization that provides hairpieces to financially disadvantaged children. Tony resumed the haircut by styling Cynthia's shoulder-length hair. Her new identity took shape. Even without her long hair, Cynthia would still be Cynthia.

Cynthia's hair loss hit me harder than I had anticipated. Thankfully Tony was able to support Cynthia during this emotional time, something I was not prepared to do. In the days that followed, more and more people came forward to provide Cynthia (and I) with the emotional and physical support she (and I) needed.

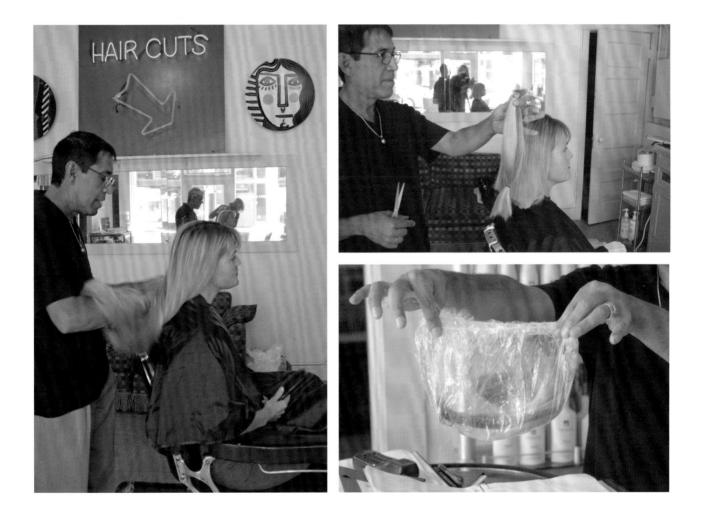

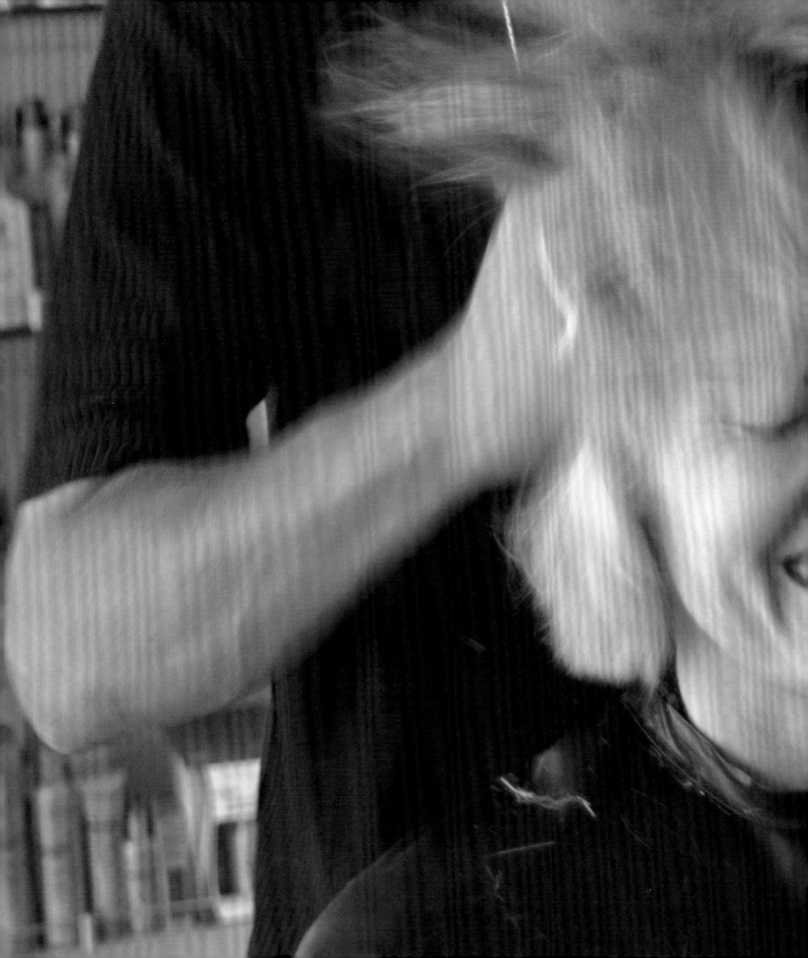

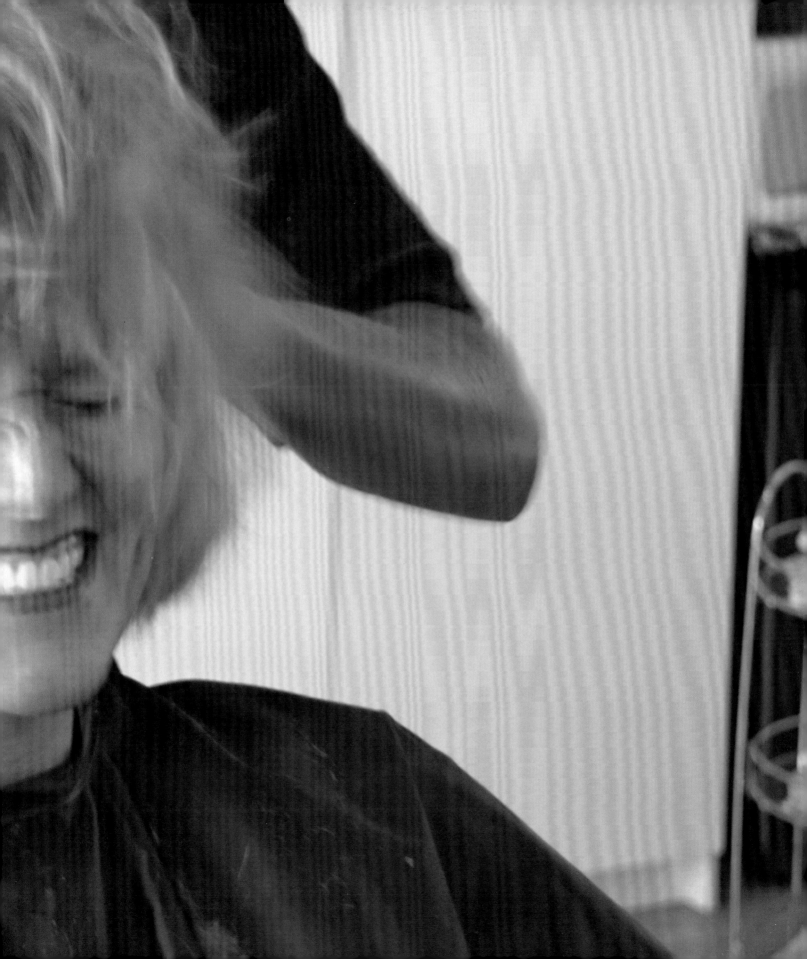

Cynthia had approximately two weeks before her hair follicles would become dormant. She was close to day seventeen of the chemo regime when she said, "I want to show you something." She ran her fingers through her hair, and showed me a fistful of blonde strands. "My hair is officially falling out." Cynthia then outlined her plan to have her mother shave her head while I photographed the milestone event.

The following day, I returned to Cynthia's home with my camera. I checked the light on the back patio. Outside I noticed the electric razor and scissors lying on the patio table. Cynthia and her mother joined me and we spoke little. Cynthia took her position on the patio stool, and Karolyn plugged in the razor. First, she cut large clumps of hair with a pair of kitchen utility scissors. Cynthia cried, almost to herself, as long masses of hair fell gently to the ground. On Cynthia's face, I saw moments of acceptance mixed with fear and sadness. Karolyn's face was expressionless as she cut her daughter's hair and then shaved her head.

Afterwards I followed Cynthia to the bathroom, photographing her in the mirror as she splashed water on her face and stared at the transformed reflection. Just before I walked away, I witnessed Cynthia touching her scalp.

Outside, Cynthia's hair remained on the ground. She had chosen that location so it might serve the birds and other creatures of the neighborhood. Hair that would no longer serve Cynthia as she progressed through her treatments could serve as nesting material. It was the second time Cynthia considered others while losing something so precious to her: first, her hair donated for wigs, and then this. It was so like Cynthia to give in the midst of her loss.

I drove home that day with questions circling in my mind: How much stronger does one's inner strength become from giving? What would it be like to give without the presence of emotional upheaval? Would the depth or the scope of the giving change if one weren't faced with losing something so precious?

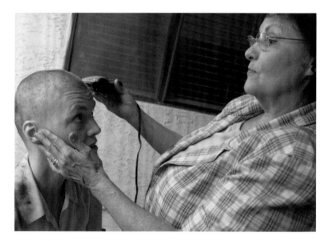

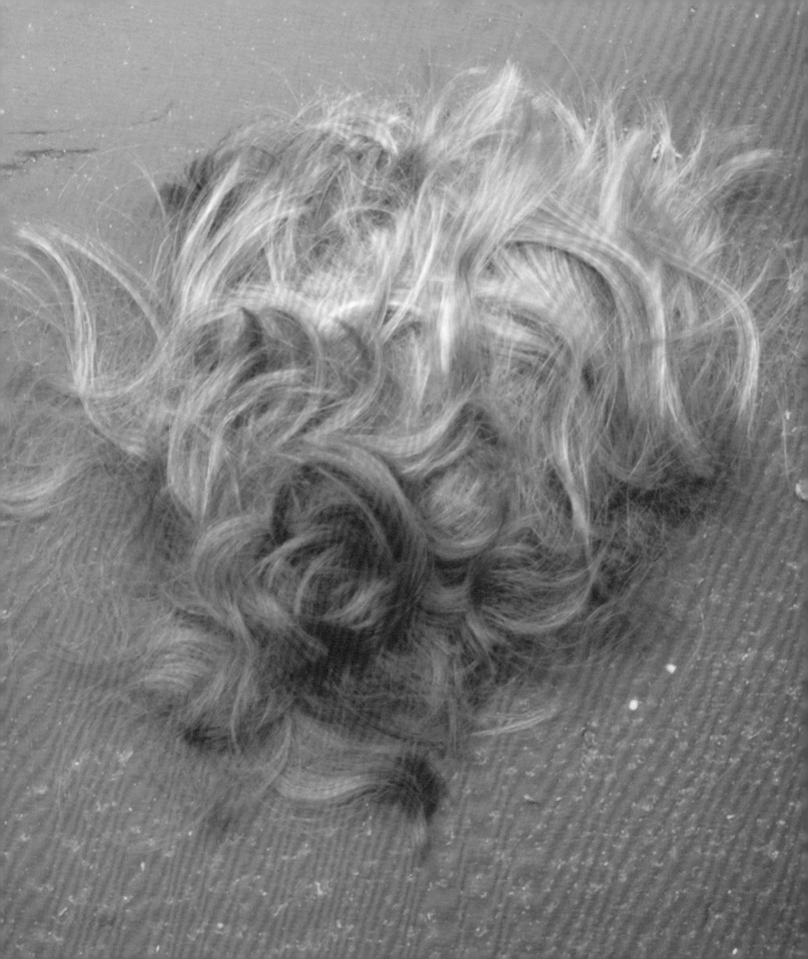

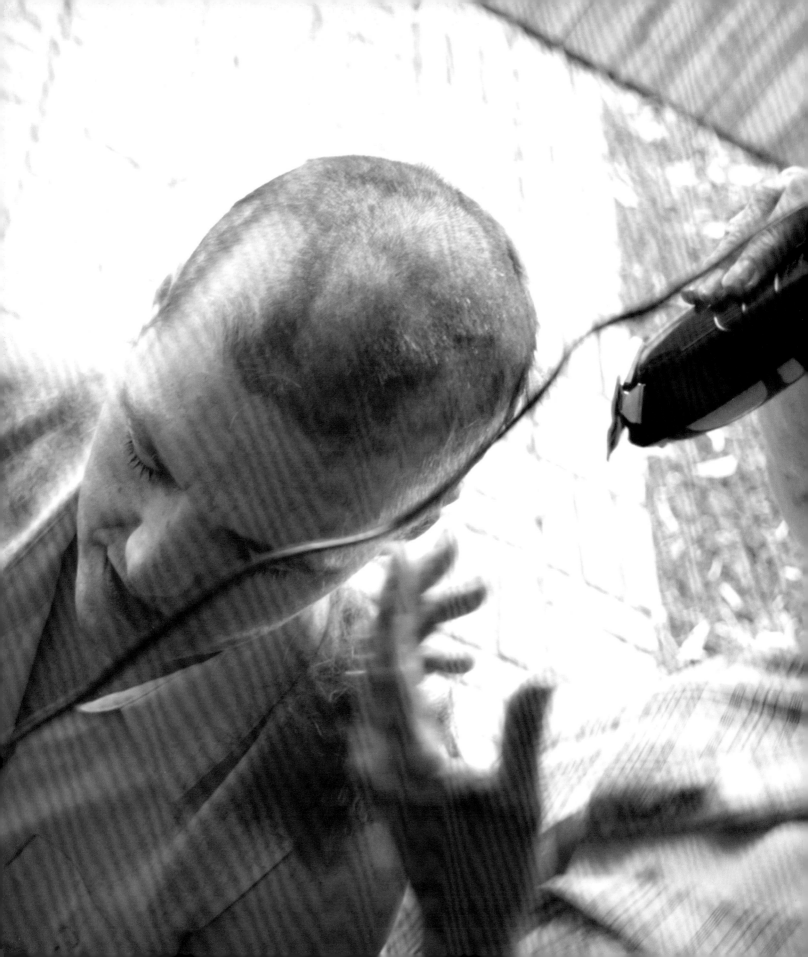

Cynthia cried, almost to herself, as long masses of hair fell gently to the ground. On Cynthia's face, I saw moments of acceptance mixed with fear and sadness. Karolyn's face was expressionless as she cut her daughter's hair and then shaved her head.

Afterwards I followed Cynthia to the bathroom, photographing her in the mirror as she splashed water on her face and stared at the transformed reflection. Just before I walked away, I witnessed Cynthia touching her scalp.

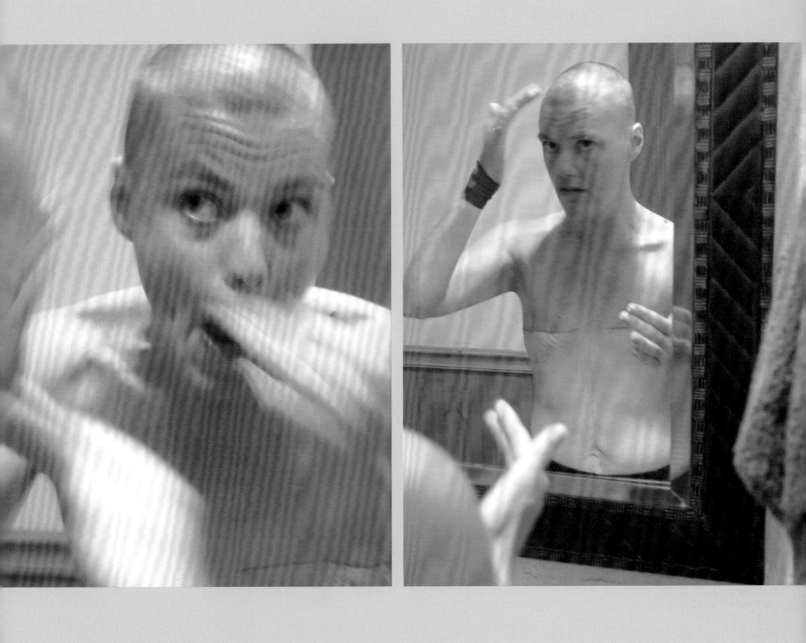

SUDDEN RUSH OF TEARS

Two months after Cynthia was diagnosed with breast cancer, I was overcome with emotion while showering. I felt the warm water rinse over my body, and just as I picked up the shampoo bottle, I burst into tears. At that moment, I got it. I felt the connection and the grief in the loss of body parts.

What does showering feel like without breasts and hair? Does it hurt to wash your chest? How does water feel on an exposed scalp? For the first time I asked, "Why Cynthia? Why not me?" My breasts put me, too, at risk for breast cancer.

All of a sudden, life felt short.

I hadn't said what I wanted to say.

I should have had more fun.

I stood frozen with the shampoo bottle in my hand. I wondered if I could have the level of courage it takes to journey as Cynthia had.

The bilateral mastectomy affected the musculature of Cynthia's chest, which limited the movement of her arms and shoulders. Along with range-of-motion exercises that Cynthia performed on her own, at home, she decided she needed physical therapy. Because this option is not offered, Cynthia requested a physical therapy referral from her physician.

Three times a week for one month, Cynthia and the physical therapist worked diligently to loosen the musculature and retrain her muscles to move as they once had.

One day I drove to a physical therapy session with Cynthia. "My goal is to raise my arms above my head without limitation," she said.

She paused.

Then she hit the steering wheel with her hand and said, "I WILL raise my arms without limitation." With such determination in her voice, surely nothing would stand in the way of her recovery.

At the session, I stood in the back of the room among the exercise equipment and watched the dance between Cynthia's listening and her creative movements to the therapist's instruction. Witnessing Cynthia's willful intention to gain control of her body, and her therapist's commitment to teach, assist, and empower her was inspiring.

In their short-term collaboration, Cynthia regained full range of motion in both her arms and shoulders, thanks, in part, to the unyielding support of her physical therapist, another essential member of her caring community. His expertise was critical in the full recovery of Cynthia's body from surgery.

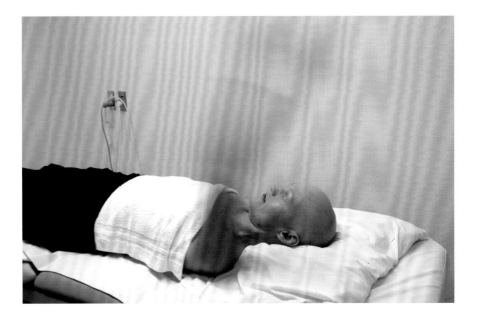

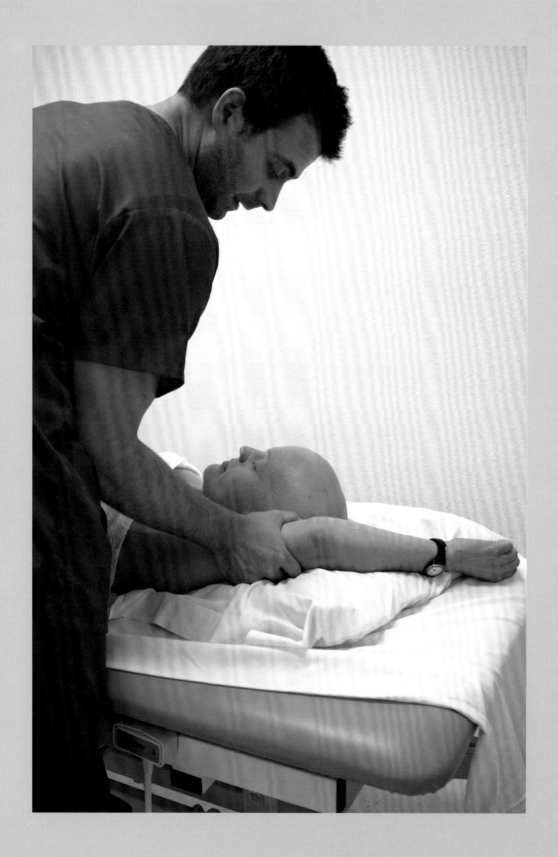

Breast cancer entered Cynthia's life arbitrarily in the spring of 2005. The intrusion was unwelcome and unscheduled. Cynthia had already planned to spend large portions of the upcoming months preparing for recertification exams in internal medicine scheduled for the fall of that same year.

Haroon was scheduled for his review at the same time. Even before the diagnosis, the two had agreed to support each other's study and preparation for the daunting board review.

Despite the fuzziness that clouded her mind from time to time during her treatments, Cynthia honored her earlier agreement with Haroon, who arrived at her house for afternoon study sessions. Occasionally Cynthia protested because she did not feel well, but Haroon always kept the appointments.

I watched from the kitchen one day as they settled into the living room with thick textbooks. Cynthia's voice grew loud with assertiveness, then sparkled with a young girl's laughter as they began a case study. The two joked about Cynthia's previous day at the cancer clinic. I believe the humor eased some pain of the journey so far. Each jovial exchange cleared the foggy traces of chemotherapy and seemed to sharpen Cynthia's senses. Learning revived her.

Unknowingly, Haroon had provided a level of support perfectly matched to Cynthia's needs at that time. He represented her community of colleagues from the hospital and fulfilled what Cynthia called her "intellectual need."

Still, I worried. Would her ability to concentrate and easily absorb information be hampered by the months of treatment? Would she be ready for the board review?

Later Cynthia received notification that she had passed her Internal Medicine Board Review. She was sure to tell me that she had correctly answered all of the questions pertaining to cancer and that her overall score was in the high 90th percentile.

Providing support for a person with cancer takes many forms: sending a letter, placing a call, visiting for ten minutes, going to the store, cleaning the house, preparing a meal, providing transportation, picking up a prescription, cutting hair, massaging the body, praying, starting an IV, and drawing blood. There are so many ways to support a person with cancer; I can't mention them all here.

Cynthia, who never cared for dogs prior to her illness, began to anticipate the presence of Jacques, the pet therapy dog, at the cancer clinic. Even a dog provided support. By allowing himself to be touched and by simply being present in the waiting area, Jacques supported Cynthia. His wet nose and furry body were happy distractions from the hours of waiting.

What I learned was that one can never tell from whom or from where necessary support will present itself. People we expect to be present may slip away; unexpected angels may appear in our lives. If we remain open, not only will the role of the caregiver blossom, but the sources of care and support may surprise us.

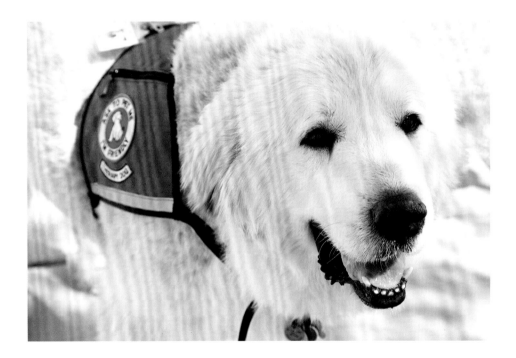

HALFWAY THROUGH CHEMO

The summer was growing long, and we were only halfway through the chemo treatments. The Tucson summer heat was stifling, and a feeling of stagnation overcame me. The combination of the heat and feeling like Cynthia and I were on a boat without an engine in the middle of an ocean, prompted me to take action and lighten things up. I went shopping and bought pink-striped kitchen towels as a gift to celebrate the milestone. After all, we weren't going anywhere, but we were halfway through chemo treatments and, even without an engine, we were getting closer to the coastline.

A week later, I escaped the heat with a trip to visit my family in Pittsburgh. Aunt Sue, my mother, and I accompanied my cousin Kristin, who had flown in from New York, to a coat salon in downtown Pittsburgh, where she wanted to buy a very special coat. Aunt Sue and Kristin love shopping with my mother.

While shopping at the salon, I found a French silk scarf with pink, burgundy, and red stripes that had a woven texture and appeared to be one of a kind. I thought of Cynthia and how her bald head is sensitive to air, even warm air. The owner of the salon stood close by as I mentioned Cynthia's bald head to my mother and the idea of purchasing the scarf. I noticed the owner walk away. Moments later he appeared from the next room with a swatch of mink that was dyed pink. A breast cancer ribbon was pinned to the middle of the mink with a pearl pin. He said he had overheard us talking and wanted to give this pin to the woman we had been discussing. He also discounted the scarf.

This unanticipated act of generosity on my voyage back through family territory underscored the oneness of our existence and the power of the simple act of giving. Suddenly I felt a little gust of wind push our boat closer to the shore. With the help of strangers, Cynthia could find safe harbor.

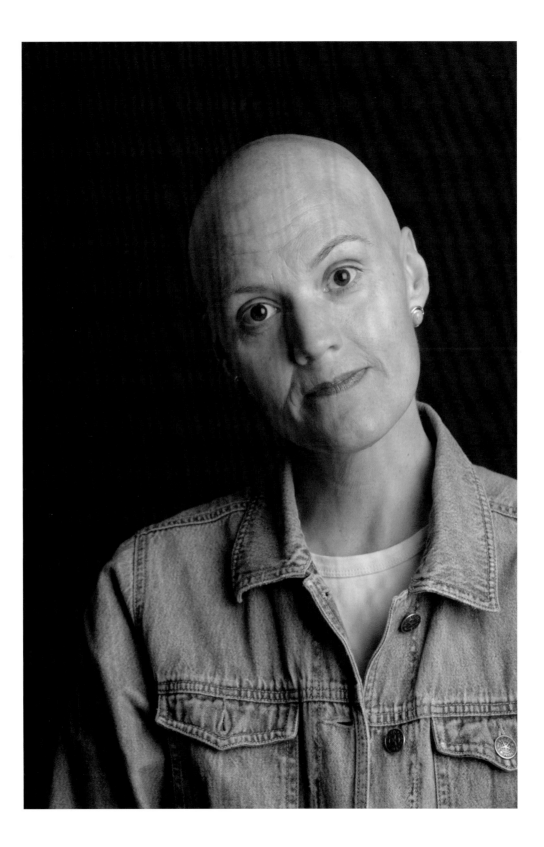

When I returned to Tucson, Cynthia was in one of her cycles of nausea and pain. We had learned to anticipate these after each chemo treatment.

Typically cancer patients are given medications in addition to chemo at each treatment. Among these are an antinausea medication, a steroid medication to prevent itching, and a medication to relax. Some of these are long acting and can last two to five days before being metabolized by the liver and excreted by the kidneys. For Cynthia these medications averted certain side effects of the chemo. They increased Cynthia's appetite and delayed the onset of bone pain after each treatment. We could predict that once the medications wore off, there would be nausea and the pain would increase.

The chemo made foods taste different and left an ongoing metallic taste in Cynthia's mouth. It kept her from drinking beverages in aluminum cans. She got food cravings. She began to fancy cottage cheese and ketchup, and scrambled eggs and cheddar cheese. A simple treasure was to find different cheeses to incorporate into scrambled eggs. I was successful with an Asiago cheese blend from an Italian deli.

In between chemo treatments, Cynthia's pain would lessen. She would feel better, and her appetite would increase. Then it would be time for the next dose of chemo, and the cycle would begin again.

To me it felt like the cancer was winning.

Chemo also has a side effect of dehydration. During the chemo treatment, Cynthia received an intravenous solution to hydrate her body. And in the days after the chemo, it was up to Cynthia to drink a lot of water. After one particular chemo treatment, Cynthia became weak. Her skin grew pale, and she was short of breath when she walked up stairs in her home.

She called her doctor and, after an evaluation, it was determined that she needed a blood transfusion. Because of the chemo, her red blood cells couldn't regenerate fast enough, and, despite the medication she received to boost red blood cell production, she had become anemic.

To me it felt like the cancer was winning. I saw the blood transfusion as a setback. As a nurse, I know the unwanted side effects that can come from blood transfusions. Fear overcame me.

Cynthia received two units of blood and felt better right away. In fact we walked in the park the next day. Instead of the blood transfusion being a bad thing, it was a necessary bend in the road of cancer. It nourished her body and gave her strength.

From that point on, we were mindful of food that was either naturally full of iron or iron enriched. I checked the Internet to get a list of the iron content of foods, and we became patrons of the local steakhouses in Tucson at lunchtime.

I saw the blood transfusion as a setback.

THE INHERITANCE

Ruthann, a high-school friend from Oregon, came to Tucson to support Cynthia during a chemo treatment. Cynthia felt great after her blood transfusion. Ruthann was also more than willing to become a patron of the local steakhouses.

After a steak lunch, we sat around Cynthia's kitchen table and talked. I noticed a tiara sitting on the kitchen countertop and asked if it was Ruthann's. We took turns trying it on while Cynthia gave us the history: the tiara was given to her by her mother, who was also a breast cancer survivor.

I've always associated tiaras with beauty and pageantry. Tiaras are passed from queen to queen. They symbolize beauty, royalty. In this case, however, the inheritance was cancer.

Cynthia had become a queen of endurance, another quality she shared with her mother.

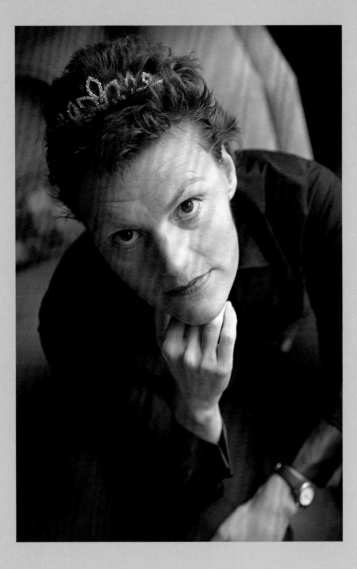

I've always associated tiaras with beauty and pageantry. Tiaras are passed from queen to queen. They symbolize beauty, royalty. In this case, however, the inheritance was cancer.

MEMORY LOSS

On the days that Cynthia felt well, we walked. One evening we returned from a walk and relaxed in the living room. Cynthia said she was losing her memory. "I can't remember where I put the hairbrush or the car keys. I can't remember if I've paid bills, and sometimes I lose track of a conversation." There were tears in her eyes as she spoke.

I reminded her that some forgetfulness was normal given the level of stress her body was under, and suggested we keep track of the forgetfulness to determine if there was a pattern. Admittedly I didn't know what to say as we sat across from each other. Was she forgetting the things we all forget, or was chemo changing her forever? If she was experiencing memory loss, was it temporary?

I realize now that I didn't need to have an exact answer for Cynthia when she spoke of forgetfulness. Instead I could have just listened and watched as she became teary eyed, and shook my head to acknowledge her voice.

Because I thought that Cynthia looked to me for answers, I felt I should provide those answers. This created a burden of pressure for me, yet this was a pressure I placed wholly on myself.

Tears, a raised voice, excessive talking, or silence are all ways of being that require support. Simply being present is more important than having the right thing to say, especially during emotional moments.

Because I thought that Cynthia looked to me for answers, I felt I should provide those answers. This created a burden of pressure for me, yet this was a pressure I placed wholly on myself.

ARTIFICIAL BREASTS

Cynthia's decision to forgo reconstructive surgery led to yet another decision: whether to appear flat chested or to opt for artificial breasts. While neither is appealing, Cynthia, nonetheless, explored her options.

Rebecca, Stephanie, and I accompanied Cynthia during the fitting for what would be her new embellishments: prosthetic breasts. The pros and cons of options were discussed; the fitting consultant and Cynthia determined her new cup size and then chose comfortable special bras with pockets for the breasts to fit into. We felt the skinlike quality of the artificial breasts as Cynthia modeled the utilitarian-style bras.

I photographed while the consultant did her work, and Cynthia had us all laughing when she announced the prosthetics looked like chicken filets.

While the consultant provided the same care to Cynthia she had given to countless women, I saw her as a key member of the community of people who supported Cynthia in her journey.

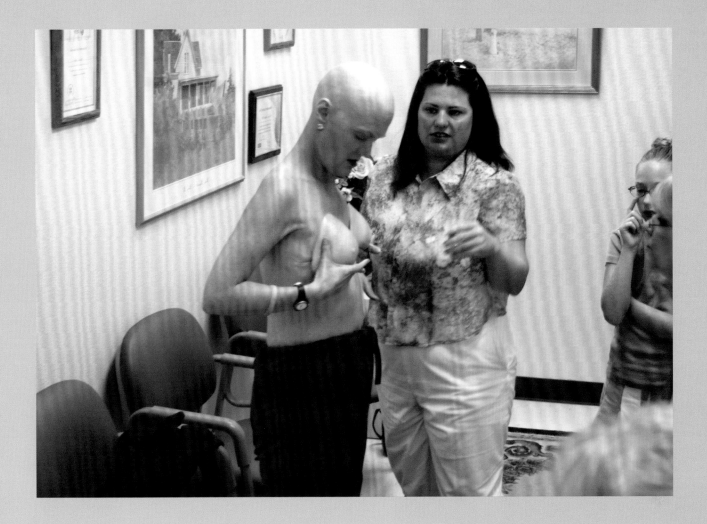

While the consultant provided the same care to Cynthia she had given to countless women, I saw her as a key member of the community of people who supported Cynthia in her journey.

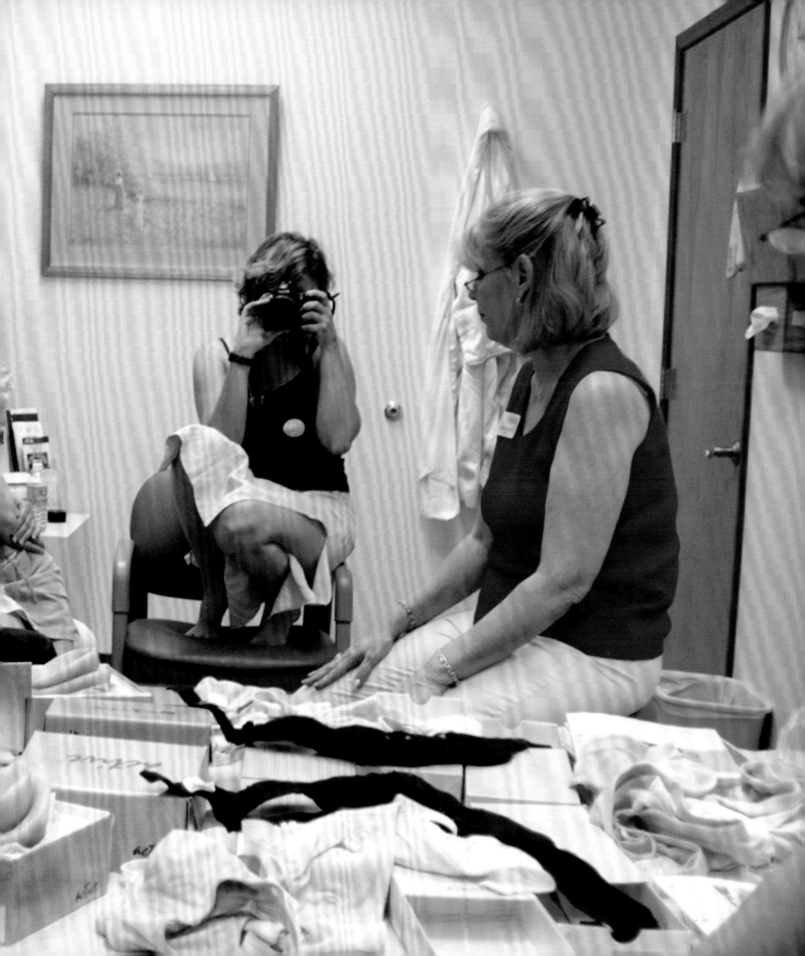

I went with Cynthia on her last day of chemo, as did our friend Vicki, who traveled from New York. Cynthia wore a head scarf, comfortable clothing, long sleeves, socks with sandals, and two cross necklaces, one of which was a Native American beaded cross necklace given as a gift from Vicki.

A nurse sat close to Cynthia and prepared the alcohol swabs, gauze, and syringes for the intravenous solutions and medications. I watched as Cynthia and the nurse discussed the placement of the angio-catheter, a plastic-sheathed needle. Because Cynthia had elected not to have a semipermanent catheter, she underwent this procedure with each chemo dose.

After the angio-catheter was placed, Cynthia was given medications to avert the side effects of chemo. Then the chemo medication arrived, freshly prepared by the pharmacy department. The medical staff that handled the chemo wore gloves. I watched as the nurse spiked the chemo bag and prepared the pump to run the chemo drip.

The chemotherapy drips over a variable time period. The infusion can last about six hours, yet the time varies with each dose of chemo. Those of us who accompanied Cynthia to the cancer clinic packed bags with the comforts of home, such as Cynthia's favorite pillow, snacks, books, and water, as well as materials for our own personal leisure activities, like knitting or Sudoku puzzles.

While the chemo dripped, Cynthia would intermittently sleep, eat crackers and cheese, or read. She'd read the Bible along with a variety of other books. Those who stayed with her often slept too, completed crossword puzzles, or took walks around the cancer center. The chemo infusion room was generally quiet with low-sounding voices. It was a restful time for most.

Once the chemo infusion was complete—around six hours—a nurse, wearing gloves, disposed of the empty chemo bag and IV tubing in a biohazard container. The angio-catheter was removed from Cynthia's arm, and Cynthia began her goodbyes. The nurses did the same and escorted her to the door. Those supporting Cynthia were responsible for repacking personal items.

On any other day, Cynthia would be given discharge instructions and scheduled for her next visit, but on this particular day—her last day of chemo—her departure from the clinic was preempted by a short celebration. The nurses gathered around to blow bubbles, spread their cheer, and acknowledge the completion of Cynthia's treatment. Indeed this was a milestone worthy of celebration. In recognition of her achievement, the cancer clinic gave Cynthia a snapshot of the bubble-blowing ceremony and a certificate of completion.

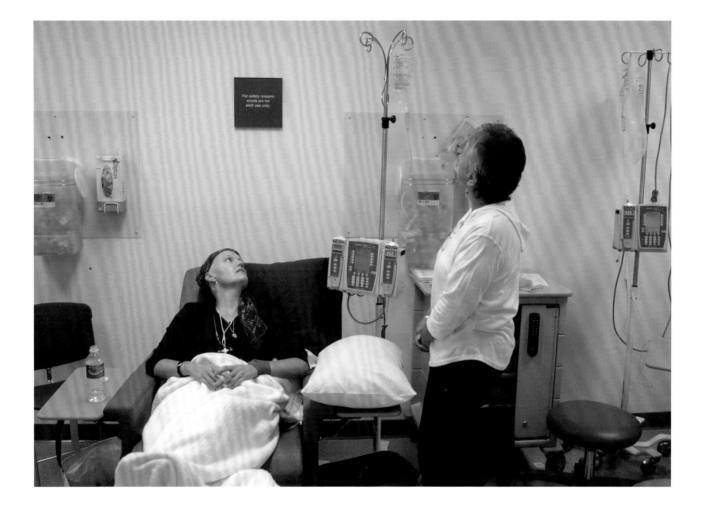

The nurses gathered around to blow bubbles, spread their cheer, and acknowledge the completion of Cynthia's treatment.

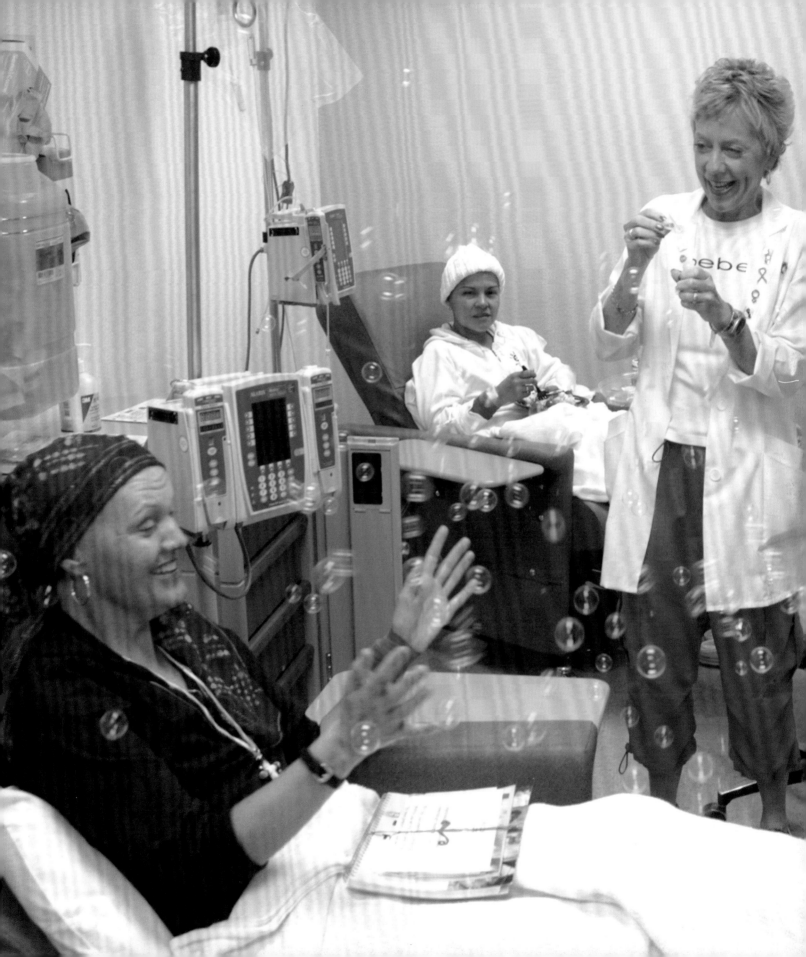

WALKING FOR BREAST CANCER

During the year Cynthia was diagnosed, I attended the Susan G. Komen Race for the Cure in Tucson. Because it was close to my house, I packed my camera and ventured among the multitudes that had converged just blocks away. The race had taken place on the same site for years, but I never attended until breast cancer touched my life.

I didn't participate in the race. Instead I set out to capture with photographs the nearly twelve thousand participants who gathered to support breast cancer survivors and memorialize those who had not survived.

As I approached the crowd, I was struck by the mass of moving pink waves. Walkers, workers, and even transport buses were adorned in the symbolic color of breast cancer: pink. The overall atmosphere was jovial, and the crowd was abuzz.

A chain-link fence marked the periphery of the park. On that particular day, the fence was decorated with bras covered with handwritten words that reflected feelings of grief and loss, or exuberance.

Later that day, the evening news reported that an estimated eighty thousand dollars had been raised from the walk. I turned down the television and thought about what I had just heard.

The enthusiasm I witnessed earlier in the day had generated money to finance breast cancer research, which promoted the possibility of breast cancer survival for thousands.

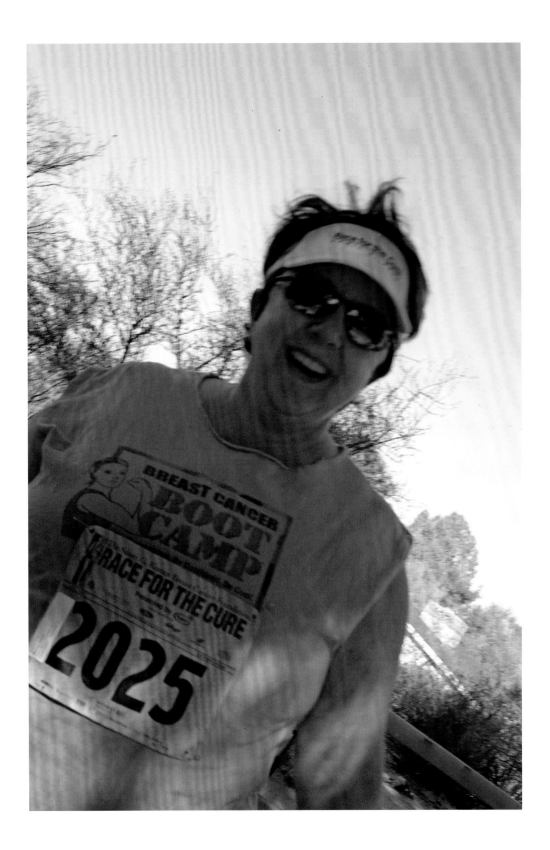

ONE YEAR

Shortly after the completion of chemo, in September, Cynthia went back to work, and we focused on our own daily routines. She committed to running a half-marathon and became enthralled with training for it. I refocused on my work as an ER nurse. It seemed as if our journey with breast cancer had ended.

Months later, March marked the one-year anniversary of Cynthia's breast cancer diagnosis and we met for a photo session.

The cover photograph of this book is one of many photographs from that session. For me the cover image symbolizes the beginning of a life-changing project and the end of a yearlong journey.

The cover photograph of this book is one of many photographs from that session. For me the cover image symbolizes the beginning of a life-changing project and the end of a yearlong journey.

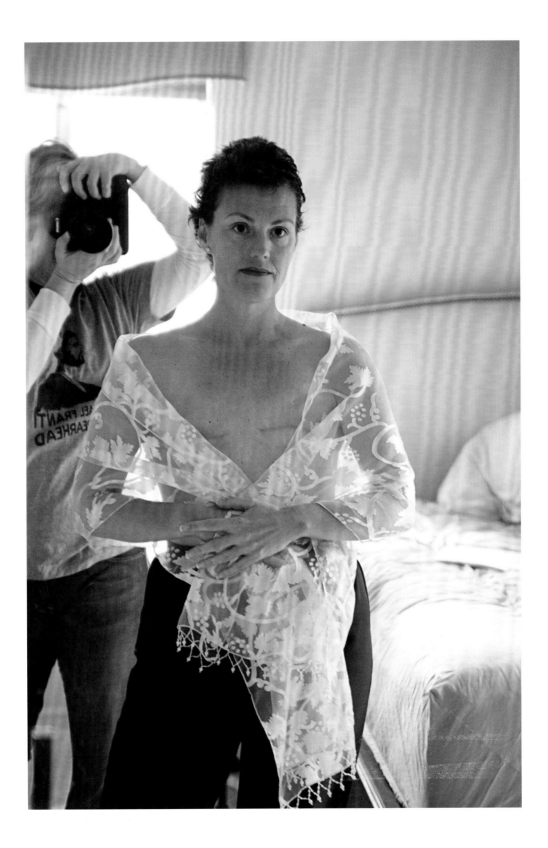

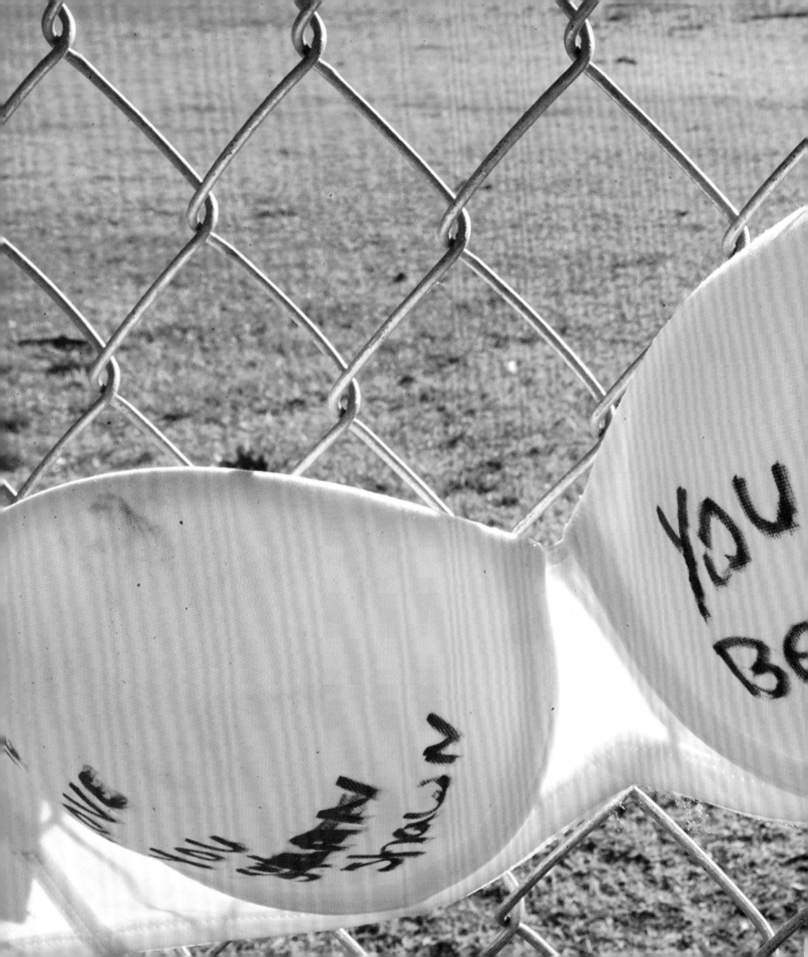

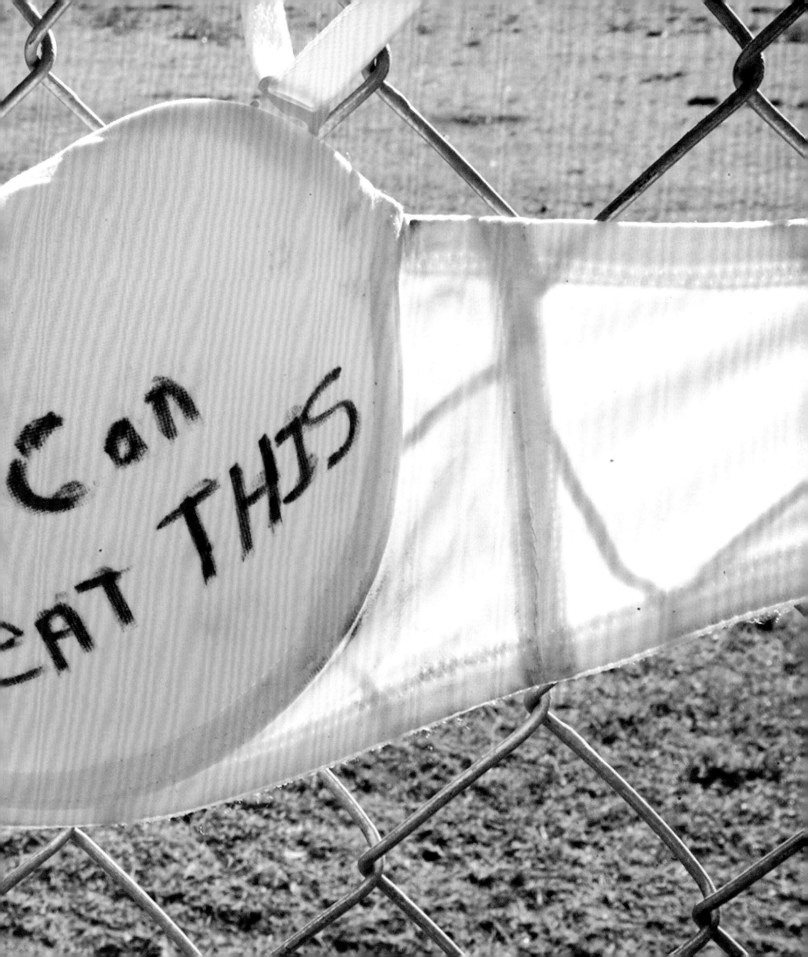

AFTERWORD

Cynthia is a breast cancer survivor. These days she lives a full life in her career as a physician, through her work with the church and the children at Sunday school, and all that she gives in friendship to the community that once surrounded her so closely. She is learning private pilot skills and travels to spend time with her family members all over the United States. She is learning how to swim and is committed to going to central Africa to teach medicine at Hope Africa University and the Frank Ogden School of Medicine for five weeks next year. She's kept her hair short and curly. Most noticeably there is a level of open-mindedness and willingness to experience life. She's unstoppable in achieving the goals that she sets for herself. Cynthia says the cancer changed her, and she describes the love she experienced from others during her journey as "transformational."

Just the other day, we set time aside to walk two miles of the Rillito Wash. It was a cool, wet day in Tucson. The desert smelled of rain, but we hardly noticed the drizzle as we walked and talked.

I was blessed to have the loyalty and the support of Cynthia's care team. No one should minimize the role they play when caring for others, ever. The care team is where I believe Cynthia found comfort, kindness, and graciousness, all of which fueled her will to survive.

My wish is that someone gives love and support to each person on a journey with cancer, and that a community blossoms to illuminate that journey with light and abundance.

The Rillito Wash

American Cancer Society

The American Cancer Society (ACS) is the nationwide community-based voluntary health organization dedicated to eliminating cancer as a major health problem by preventing cancer, saving lives, and diminishing suffering from cancer, through research, education, advocacy, and service.

American Cancer Society
National Home Office
250 Williams Street NW
Atlanta, GA 30303
P: 800.227.2345
www.cancer.org

CancerCare

CancerCare is a national nonprofit organization that provides free, professional support services for anyone affected by cancer.

CancerCare National Office
275 Seventh Avenue, Floor 22
New York, NY 10001
P: 800.813.4673
P: 212.712.8400
F: 212.712.8495
E: info@cancercare.org
www.cancercare.org

Coalition of Cancer Cooperative Groups

The Coalition of Cancer Cooperative Groups (CCCG) is a nonprofit organization whose mission is to improve the quality of life and survival of cancer patients by increasing participation in cancer clinical trials.

Coalition of Cancer Cooperative Groups
1818 Market Street, Suite 1100
Philadelphia, PA 19103
P: 877.520.4457
F: 215.789.3655
E: info@cancertrialshelp.org
www.cancertrialshelp.org

Fertile Hope

Fertile Hope is a national nonprofit organization dedicated to providing reproductive information, support, and hope to cancer patients and survivors whose medical treatments present the risk of infertility.

Fertile Hope
65 Broadway, Suite 603
New York, NY 10006
P: 888.994.4673
P: 212.242.6798
F: 212.242.4570
E: info@fertilehope.org
www.fertilehope.org

Gilda's Club

Gilda's Club provides meeting places where men, women, and children living with cancer, along with their families and friends, can join with others to build a personal network of social and emotional support as an integral part of cancer treatment.

Gilda's Club Worldwide
322 Eighth Avenue, Suite 1402
New York, NY 10001
P: 888.445.3248
F: 917.305.0549
E: info@gildasclub.org
www.gildasclub.org

Living Beyond Breast Cancer

Living Beyond Breast Cancer (LBBC) is a nonprofit organization dedicated to empowering all women affected by breast cancer to live as long as possible with the best quality of life.

Living Beyond Breast Cancer
10 East Athens Avenue, Suite 204
Ardmore, PA 19003
P: 610.645.4567
F: 610.645.4573
E: mail@lbbc.org
www.lbbc.org

Men Against Breast Cancer

Men Against Breast Cancer (MABC) is the first national nonprofit organization designed to provide targeted support services to educate and empower men to be effective caregivers when breast cancer strikes a female loved one; as well as target and mobilize men to be active participants in the fight to eradicate breast cancer as a life-threatening disease.

Men Against Breast Cancer
PO Box 150
Adamstown, MD 21710
P: 866.547.6222
F: 301.874.8657
E: info@menagainstbreastcancer.org
www.menagainstbreastcancer.org

Myself: Together Again

Myself: Together Again (M:TA) is a project to empower young women through the breast reconstruction process.

Myself: Together Again
PO Box 6451
Raleigh, NC 27628
E: info@myselftogetheragain.org
www.myselftogetheragain.org

National Alliance for Caregiving

The National Alliance for Caregiving (NAC) is dedicated to providing support to family caregivers and the professionals who help them and to increasing public awareness of issues facing family caregivers.

National Alliance for Caregiving
4720 Montgomery Lane, 5th Floor
Bethesda, MD 20814
P: 301.718.8444
F: 301.951.9067
E: info@caregiving.org
www.caregiving.org

National Coalition For Cancer Survivorship

The National Coalition for Cancer Survivorship (NCCS) is the oldest survivor-led cancer advocacy organization in the country, advocating for quality cancer care for all Americans and empowering cancer survivors. NCCS believes in evidence-based advocacy for systemic changes at the federal level in how the nation researches, regulates, finances, and delivers quality cancer care.

National Coalition for Cancer Survivorship
1010 Wayne Avenue, Suite 770
Silver Spring, MD 20910
P: 301.650.9127
F: 301.565.9670
E: info@canceradvocacy.org
www.canceradvocacy.org

National Family Caregivers Association

The National Family Caregivers Association (NFCA) educates, supports, empowers, and speaks up for the more than 50 million Americans who care for loved ones with a chronic illness or disability or the frailties of old age. NFCA reaches across the boundaries of diagnoses, relationships, and life stages to help transform family caregivers' lives by removing barriers to health and well-being.

National Family Caregivers Association
10400 Connecticut Avenue, Suite 500
Kensington, MD 20895
P: 800.896.3650
P: 301.942.6430
F: 301.942.2302
E: info@thefamilycaregiver.org
www.nfcacares.org

National Hospice and Palliative Care Organization

The National Hospice and Palliative Care Organization (NHPCO) is committed to improving end-of-life care and expanding access to hospice care with the goal of profoundly enhancing quality of life for people dying in America and their loved ones.

National Hospice and Palliative Care Organization
1700 Diagonal Road, Suite 625
Alexandria, VA 22314
P: 703.837.1500
F: 703.837.1233
E: nhpco_info@nhpco.org
www.nhpco.org

Susan G. Komen for the Cure

Susan G. Komen for the Cure is the world's largest grassroots network of breast cancer survivors and activists fighting to save lives, empower people, ensure quality care for all, and energize science to find the cures.

Susan G. Komen for the Cure
5005 LBJ Freeway, Suite 250
Dallas, TX 75244
P: 877.465.6636
www.komen.org

Y-Me National Breast Cancer Organization

The mission of Y-ME National Breast Cancer Organization is to ensure, through information, empowerment, and peer support, that no one faces breast cancer alone.

Y-ME National Breast Cancer
Organization Headquarters
212 W. Van Buren, Suite 1000
Chicago, IL 60607
P: 312.986.8338
F: 312.294.8597

24/7 Breast Cancer Support
P: 800.221.2141 (English)
P: 800.986.9505 (Español)
www.y-me.org

Young Survival Coalition

Through action, advocacy, and awareness, the Young Survival Coalition (YSC) seeks to educate the medical, research, breast cancer, and legislative communities and to persuade them to address breast cancer in women 40 and under. The YSC also serves as a point of contact for young women living with breast cancer.

Young Survival Coalition
61 Broadway, Suite 2235
New York, NY 10006
P: 877.972.1011
P: 646.257.3000
F: 646.257.3030
E: info@youngsurvival.org
www.youngsurvival.org

ARTIST'S STATEMENT

A camera explicitly, and sometimes unpredictably, records the emotions and surroundings that make up a brief moment in time. Once captured, the image is used to interpret this ephemeral moment. Whether we accept the reality it presents or whether we deny it, the revealing nature of photography allows us to feel the moment again and again.

When my best friend, Cynthia, and I learned she had breast cancer, we were in denial about the reality of the diagnosis. As we began to accept it, we used photography as a medium to document our reality while, at the same time, escape it. In accepting breast cancer, we controlled how we reacted to it by becoming subjects of an educational documentary that would move, touch, and inspire others. We faced each emotional challenge with a steadfast acceptance, simply out of our promise to document that experience for others.

Each person's experience with breast cancer is personal. The images created during the year of Cynthia's cancer and treatment were captured through my perspective—that of the caregiver. My close relationship with Cynthia and my photographic style of capturing people simply being themselves will serve as a visual support for those patients and caregivers recently touched by cancer. It is my intention that the images inspire dialogue when moments of adversity or triumph surface, and that they serve as a platform from which one can begin to experience cancer.